D1389429

LEONARDO
DA VINCI

LEONARDO DA VINCI

CYNTHIA PHILLIPS & SHANA PRIWER

A DAVID & CHARLES BOOK
© F&W Media International Ltd 2011

David & Charles is an imprint of F&W Media International, Ltd
Brunel House, Forde Close, Newton Abbot, TQ12 4PU, UK

F&W Media International, Ltd is a subsidiary of F+W Media, Inc., 4700
East Galbraith Road, Cincinnati OH45236, USA

Text copyright © F+W Media Inc. 2011

The material in this book has been previously published in *The Everything
Da Vinci Book*, published by Adams Media, 2006.

F+W Media Inc. has asserted the right to be identified as author of this
work in accordance with the Copyright, Designs and Patents Act, 1988.

A catalogue record for this book is available from the British Library.

ISBN-13: 978-1-4463-0167-8
ISBN-10: 1-4463-0167-2

Printed in Finland by Bookwell
F&W Media International, Ltd
Brunel House, Forde Close, Newton Abbot, TQ12 4PU, UK

10 9 8 7 6 5 4 3 2 1

Project Editor: Freya Dangerfield
Senior Editor: Verity Muir
Senior Designer: Jodie Lystor
Production Manager: Bev Richardson

F+W Media publishes high quality books on a wide range of subjects. For
more great book ideas visit:
www.rubooks.co.uk

CONTENTS

INTRODUCTION

L eonardo da Vinci is one of the most celebrated artists of all time. He is the master responsible for creating the magnificent *Mona Lisa* painting, a credential that alone should serve to distinguish his career from any other before or after. However that is not all. Content to be not only an amazing artist, Leonardo was also a talented scientist and inventor who was one of the first to make detailed anatomical studies and the first to conceptualize a robot in human form. One of the few shortcomings of this breathtaking talent was that he had more ideas than he could possibly realize in a lifetime.

Leonardo's artistic talents were more than apparent from a very early age, and when he was 16 years old his father apprenticed him to leading Florentine artist Andrea Verrochio. Leonardo rapidly proved himself then went on to surpass his master, quickly stamping his own distinct mark on the world. He embraced an itinerant lifestyle moving around Italy from city to city with ease, establishing himself in each location as an acclaimed artist and yet constantly striving to prove himself in another diverse field. Throughout his long career, Leonardo enjoyed the artistic patronage of a prestigious collection of masters who ranged from kings and dukes, to warlords.

Leonardo wasn't simply a painter – he travelled as a military engineer with the infamous Cesare Borgia, putting his immeasurable genius to task in order to create innovative machines of war. During more peaceful times Leonardo became engrossed in scientific discoveries, investigating the secrets of the human body, designing architectural wonders and inventing flying machines. Never one to shy away from a challenge, his ideas were often phenomenally visionary in scope – he even laid out plans to divert an entire river.

In spite of these other endeavours Leonardo was, and still is, predominantly

celebrated for his art, although in fact only a handful of his finished paintings survive today. This is no coincidence – Leonardo began countless projects, but finished very few. Even the paintings he did finish suffered from his constant innovation, often deteriorating as a result of the brand new application techniques he used on them. His inventions tended to suffer from the same lack of realization – most were never built, although there have been some astounding modern attempts to replicate them.

Fortunately, Leonardo's amazingly detailed notebooks answer many of the questions that his physical works leave unanswered. Of course, these fascinating notebooks themselves have their own peculiarities. Not only did Leonardo write them in an extraordinary backwards mirror writing, his notes also weren't organized or dated. On his death in 1519 Leonardo left these notebooks to his student, close friend and probable lover Francesco Melzi; sadly after Melzi's death many of the pages were dismissed as scribbles and lost or dispersed. Today what remains of Leonardo's writings has been carefully collected into magnificent codices that are reverently displayed in museums around the world.

When we look at Leonardo's accomplishments, the sheer breadth of his talents is even more remarkable than the talents themselves. Not only did he paint one of the most breathtaking and talked-about paintings of all time, he also created designs for a prototype helicopter, an enormous equestrian statue and an amazing armoured tank. Leonardo was a multitalented man and groundbreaking innovator who excelled at everything he tried. Perfectly formed to fit the definition of the ultimate Renaissance man, he arguably remains the greatest genius and artist the world has ever seen.

Where it all began
Conflicting claims over birthplace

Castello dei Conti Guidi

Leonardo was born on 15 April 1452; there is no disputing this. However doubt has recently been cast on the assumption that the town of Vinci, located 50 km (32 miles) to the west of Florence, deep in the Tuscany region of Italy, was actually the true birthplace of the genius.

In the 15th century it was customary for Italians to take the name of their birth city as part of their full identification. And so Leonardo, by virtue of being born in Vinci, was known as Leonardo da Vinci. Many scholars agree that he was, indeed, born there. However, not everyone now supports this claim; one popular conflicting theory holds that Leonardo was actually born in Anchiano, a town located about 3 km (2 miles) from the outskirts of Vinci.

What evidence is there for this? For one thing Leonardo's family supposedly lived there. Anchiano also boasts a farmhouse that many people think is where Leonardo first entered this world, fittingly nicknamed the Casa Natale di Leonardo (literally 'the birth house of Leonardo'). Today, the farmhouse is home to a permanent exhibit of Leonardo's drawings and other works. Restored in the mid-1980s, the house is decorated with many of Leonardo's landscape paintings – if nothing else it's a fascinating location in which to view a fine selection of the master's work.

Even if Leonardo was actually born in Anchiano, he clearly spent

much of his childhood in Vinci.
Vinci today is home to the Leonardo
Museum, which occupies part of
the Castello dei Conti Guidi. The
castle was converted into a museum
in 1953 to celebrate the 500th
anniversary of Leonardo's birth. The
main exhibit includes designs of some
of Leonardo's amazing machines,
including cranes, winches, clocks
and helicopters. In addition to this
museum, there are other points of
interest in Vinci. It is home to the
Santa Croce Church that boasts
Leonardo's rumoured baptismal font.
And modern-day Vinci continues
to hold yearly festivals that celebrate
Leonardo and his artistic legacy.

OTHER VINCI EXPORTS
*While Leonardo may have been
Vinci's most famous son, other artists
and products have also hailed from
this relatively small town. A talented
sculptor named Pier Francesco da
Vinci was born there in the mid-
16th century – he was Leonardo's
nephew. The Tuscan region and Vinci
in particular is also home to some
of Italy's most famous consumable
exports, including olive oil and wine.*

Illegitimate son
Inauspicious beginnings for a genius

L eonardo grew in stature to
become one of the Renaissance's
favourite sons. But what is perhaps
more remarkable is that he was born
with absolutely no advantages over
his contemporaries. His birth was
illegitimate, a distinct disadvantage
to someone of his social class in
Renaissance Italy.

His mother, Caterina, was a 16-year-
old peasant girl; his father, Ser Piero di
Antonio, was a 25-year-old notary. A
wedding was forbidden between the
two young lovers because of their class
difference, and Ser Piero was hastily

Young Leonardo

married off to a more appropriate mate named Albiera. Caterina also married a few months after Leonardo's birth.

As an illegitimate child, Leonardo's position in the highly stratified society of Tuscany was precarious at best. Class status was significant, especially in the newly developed Italian middle classes. In the upper classes, illegitimate children were treated more or less like legitimate children, and they could inherit property and social status from their fathers. However the middle classes strongly favoured legitimate birth; subsequently, as the illegitimate son of a peasant woman who was possibly slave, Leonardo's status in early life was decidedly challenged.

FAMILY PROFESSION

The family of Leonardo's father included a long line of notaries. At that time the position of notary was similar to a lawyer, and Ser Piero boasted a relatively privileged position in society. Although Leonardo's father raised his son in his household, Leonardo's illegitimacy disqualified him from the clubs and guilds to which his father belonged and the son shared none of his father's privileges. In fact, Leonardo couldn't receive a university education, and he certainly wouldn't have been able to follow in his father's footsteps to become a notary. With the gift of hindsight scholars tend to view this handicap as fortuitous, leaving Leonardo free to pursue life as an artist, and so much more.

Extended family
Leonardo's countless half siblings

Although illegitimate, Leonardo was by no means alone in the world. Both his mother Caterina

and his father Ser Piero married new partners and produced many other children, eventually – and as far as we know – leaving Leonardo with an incredible 17 half brothers and sisters.

Ser Piero's offspring

Ser Piero was married four times and produced 12 siblings for Leonardo. His first two wives Albiera and Francesca died young and bore no children. His third wife, Margherita, gave birth to two sons and one daughter:

ANTONIO (b 1476)
GIULIOMO (b 1479)
MADDALENA (b 1477, but died as a
 toddler in 1480)

Soon after Maddalena's death Margherita died as well, and Ser Piero married his fourth wife Lucrezia who gave birth to two daughters and seven more sons:

LORENZO (b 1484)
VIOLANTE (b 1485)
DOMENICO (b 1486)
MARGHERITA (b 1491)
BENEDETTO (b 1492)
PANDOLFO (b 1494)

GUGLIELMO (b 1496)
BARTOLOMEO (b 1497)
GIOVANNI (b 1498)

Caterina's offspring

Caterina bore five children after she was married, although little is known of them. What is known is that these five children included three half sisters and one half brother (nothing is known about the fifth), all of whom were closer in age to Leonardo than his father's other children.

Records show that two of Caterina's daughters were named Piera (born in 1455) and Maria (born in 1458), and Leonardo notes in his writings that his half brother on his mother's side died from a mortar shot at Pisa.

Flesh and blood
Greed amongst his father's offspring

L eonardo's father Ser Piero died in 1504 without a will, sparking a veritable feeding frenzy of greed amongst his offspring. One of Leonardo's half brothers had become a notary like his father, and swiftly

took charge of the legal proceedings. He first challenged Leonardo's right to inherit from his father's estate and then, when Ser Piero's brother Francesco died a few years later, he raised objections to the terms of their uncle's will as well.

The result was years of vicious in-fighting, and over this period it was necessary for Leonardo to return to Florence a number of times to settle disputes until the litigation finally concluded in 1511. Ultimately Leonardo received no inheritance from his father's estate, but did emerge from the years of conflict with rights to his uncle Francesco's farm, land and money.

NEPHEW OF A GENIUS

Although none of Leonardo's siblings were particularly artistic, he had a nephew Pier Francesco da Vinci (1531–1554). Nicknamed Pierino, this young man became a talented sculptor producing acclaimed works throughout Italy. Pierino didn't have the breadth of genius of Leonardo, although he also didn't have that much time to develop in skill before his death in Pisa at the tender age

of 23 years old. In spite of his short career, the 16th century art historian Giorgio Vasari (1511–1574) dedicated a biography to Pierino, and one of Pierino's sculptures entitled Young River God *can be found on display in the Louvre.*

The call of the wild
Studying the natural world around him

A distinct hallmark of Leonardo's personality was his unerring determination to learn. And perhaps the most prominent, and unusual, characteristic of self-development throughout his life was his complete respect and deep love for nature. Leonardo would spend hours on end observing nature first-hand, and his very earliest sketches were studies of landscapes, plants and animals.

Leonardo truly believed that nature was the best teacher available to an artist. He had a particular fascination for the margins to be found here, such as the line between the beautiful and the grotesque. Rather than rendering the most beautiful things

he could find, he searched instead for the unusual – strange hills and rocks, odd animals and rare plants. He also studied humans, and the detailing he used in his early drawings of faces and expressions rapidly elevated his work above that of his contemporaries.

Few dated drawings survive from Leonardo's childhood. Nevertheless one of Leonardo's earliest known drawings, a pen-and-ink landscape of the Arno Valley from 1473, is also one of the first drawings ever to detail landscape in a truly realistic, convincing style. Even in the early stages of his career Leonardo was breaking the boundaries of established artistic practice.

The story of Medusa

Giorgio Vasari's biography of Leonardo records one revealing example from Leonardo's childhood that demonstrates the remarkable work habits he adopted from an early age, and for which Leonardo would become renowned as an adult.

According to this report, Leonardo was commissioned by his father to decorate a shield for a local peasant. The young artist decided to decorate

the shield with the face of Medusa, the mythological serpent-headed creature. It is fascinating to learn that to complete the commission, Leonardo gathered the dead bodies of various snakes, lizards and other creatures from outdoors, positioning them in his studio to use as models.

After a few days of work Leonardo's father visited to see what progress his son was making. When he walked into his son's studio, Ser Piero was not only confronted with the shield's grotesque realism, he also got hit with the stench of decomposing reptiles. As the story goes Leonardo had been oblivious to his models' offensive smell and didn't object in the slightest to working amidst dead creatures, as long as they provided the accurate reference he required for his art.

MOTHER AND CHILD
Throughout his career, Leonardo spent much time sketching and painting images of mothers with children. Later psychoanalyst Sigmund Freud theorized that these works, whilst religious in nature, were actually Leonardo's attempt to

The Virgin and Child with St Anne *painting*

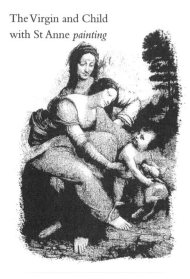

deal with being abandoned by his mother at a tender age. Maybe this is a stretch, but then again, maybe it is possible to recognize the lack of a true maternal bond in some of his works such as The Virgin and Child with St Anne. *It has been suggested that in this painting the child could well be a self-portrait, while the Virgin and St Anne might represent Leonardo's mother Caterina and his first step-mother Albiera. Although such interpretations are only theories, they do support the*

possibility that Leonardo's popular religious themes may have had personal underpinnings.

Leonardo the lefty
Left-handed artist in excellent company

Perhaps not insignificantly, it is intriguing to learn that Leonardo was in fact left-handed. Generally speaking the right hemisphere of the human brain, more dominant in left-handed people, controls art, music, creativity and emotions. In contrast, right-handed people are more orientated toward the left hemisphere of the brain, associated with mathematics, science, language and speech. Perhaps it should come as no great surprise then that Leonardo was left-handed.

Many other great artists throughout history have been left-handed, including M.C. Escher, Paul Klee and Michelangelo Buonarroti. A number of famous musicians are also left-handed – Robert Schumann, Maurice Ravel, Sergei Rachmaninoff and Ringo Starr, to name but a few.

The left-handed Leonardo was in excellent company.

WRITING BACKWARDS

Leonardo's left-handedness almost certainly influenced his unusual style of writing, which flowed from right to left. He also wrote his individual letters backward, so they formed a mirror image in appearance. This style isn't completely uncommon among left-handed people and it is believed Leonardo devised the technique as a child. Some historians even believe that Leonardo developed his backward writing as a secret code to protect his notes and sketchbooks from being copied. Whatever the reason, Leonardo's writing method most certainly served to further enhance his unique aura.

The apprentice
Development and innovation in his master's studio

When the budding artist Leonardo reached 16 years of age in 1468, his family moved to Florence. This move would ultimately transpire to be of the greatest importance to Leonardo's career as Florence was the hub of Renaissance artistic talent, and home to many of the period's finest artists including a certain Andrea Verrocchio (1435–1488). Art took many forms during the Renaissance, and Verrocchio was considered not only a master of painting, but also of sculpture, goldsmithing, music and other arts.

When the family moved to Florence Leonardo's father immediately secured an invaluable apprenticeship for his son with this great master that ensured this already outstanding talent could further develop. Apprenticeship presented distinct advantages for Leonardo. At this time there was a well-established program for interns, and Leonardo studied all the technical aspects of painting, including how mix paint

Andrea Verrocchio

and the theory of colour.

This crucial internship taught the skills of painting on wood panels, and Leonardo became an expert in the preparation and maintenance of the necessary materials. Of course the Renaissance was a time of artistic transition that saw artists moving from painting solely on wood to working on canvas too. Leonardo would have been exposed to these new canvas techniques, including learning how to stretch and prepare the surfaces, and understanding how the different materials accepted paint

in different ways. Indeed while most of Leonardo's early masterpieces were oil on wood, his later works were completed on paper and canvas.

The Renaissance was a time of transition not only from wood to canvas, but also from tempera to oil paint. The science of mixing oil paints was complex, and as an apprentice Leonardo would have spent many hours washing and grinding pigments into a thick paste, then adding this paste and other requisite ingredients to the oil to create the emulsion paint. Even as an apprentice in the heady environment of Renaissance Florence, the young Leonardo found opportunity to innovate. He significantly improved the quality of oil paint by mixing the ground pigments with linseed oil, and adding beeswax and water to the paint while it was in a boiling stage, to keep the colours light and prevent over-saturation.

Besides paints, Leonardo almost certainly learned how to make and draw with chalk while apprenticed to Verrocchio. In Renaissance Italy mineral chalks were dug out of the ground and fashioned into drawing tools. Red and brown chalks were

the most popular tools, and these are the ones that remain apparent in most of Leonardo's later chalk drawings.

Off to a cracking start
Talent shines through on his first professional work

The first significant painting on which Leonardo worked was *The Baptism of Christ*, completed in 1472. Leonardo's master Verrocchio was the official artist, but it was one of the first commissioned works in which Leonardo took part, working alongside his master as was customary for a Renaissance apprentice. This painting was destined to become largely responsible for setting Leonardo's phenomenal career off to a cracking start.

In the painting Verrocchio most likely painted Christ and John the Baptist. Although written documentation is slim, it is thought that Leonardo's particular addition to the painting, along with part of the landscape, is a kneeling angel supporting Christ's mantle. This figure appears more lifelike than the others – the angel's expression, hair

and clothing are particularly detailed betraying Leonardo's extraordinarily delicate touch. This angel was also painted in oil, Leonardo's paint of choice, whereas much of the remainder of the painting was completed in tempera.

Using diagnostic technology to examine this painting, historians have proved that Verrocchio made a master sketch before applying the paint. From this critical research it has become apparent that Leonardo followed his own creative direction and strayed from his master's overall scheme, taking excessive liberties with his portion of the painting. It can also be seen that Leonardo's rendering of the landscape, filled with shadows and bright sunlight, differs significantly from the sections painted by Verrocchio. Even at this early point in his career Leonardo was demonstrating his own creativity rather than simply following the orders of others. The success of this approach was down solely to the young artist's extraordinary talent, and we'll never know how Verrocchio reacted to his pupil's alternations to his inherent design.

The Baptism of
Christ *painting*

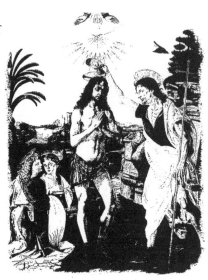

While Verrocchio's work didn't completely pale in comparison to Leonardo's, it was clear from even this early stage that Leonardo's painting abilities would eventually surpass those of his master. In fact one unverified story claims that Verrocchio swore to give up painting when he saw Leonardo's work, since he knew he could never be as good as his apprentice. The monks of the Florentine monastery of San Salvi had commissioned the painting and the masterpiece remained at their monastery until 1530; it now resides in the Uffizi Gallery in Florence.

COLLABORATIVE EFFORT

Besides Verrocchio and Leonardo, a number of other surprisingly well-known collaborators worked on The Baptism of Christ *including Sandro Botticelli and Lorenzo di Credi. Many of these artists would eventually become fantastically famous in their own right.*

Making his mark
Striking out on his own

With his first major success collaborating on *The Baptism of Christ*, Leonardo's confidence soared. His work was recognized far and wide, and this realization may have given him the push needed to leave his master's studio and strike out on his own. Although most artists based their styles on those of their masters, this move marked a momentous point at which the unusually talented Leonardo started to realize his own extraordinary ability and style.

In 1472 Leonardo joined the Company of Painters, Florence's prestigious painting guild. Guilds were abundant in Renaissance Italy and provided artists with opportunities to interact, share techniques and provide mutual support – they were also a common resource for patrons. For Leonardo, joining the Company of Painters was a crucial yardstick in his career. Whilst he continued to work from his master's studio, enrollment in the guild granted him a higher status, enabling him to receive commissions both individually and as part of the guild. As an interesting aside, the honour of belonging to a guild certainly didn't come for free; in Leonardo's inimitable style the guild's record books show that he was behind on his membership fees at least once.

During his first years with the guild Leonardo was still working in Verrocchio's studio on many projects. However after five years with the Company of Painters, Leonardo made a complete break and opened his own studio in Florence. Whilst retaining close ties to Verrocchio he began establishing his own identity, splitting from Verrocchio on several major artistic issues. For example, while Verrocchio was a master of tempera Leonardo preferred working with oil paint. Leonardo understood that oil paints had a more natural glow, and also increased his ability to mix a wide range of colours.

EMERGING HALLMARKS
The Madonna and Child with Flowers*, also known as the* Benois Madonna*, is a work completed during Leonardo's*

Benois Madonna
painting

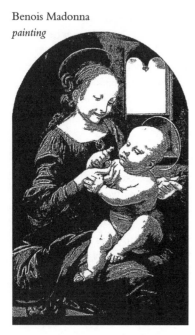

early independent period. This oil painting demonstrates Leonardo's emerging hallmarks of extremely realistic human features that convey a rich depth of expression, especially apparent in the Madonna's face and hand gestures. As with so many of Leonardo's other paintings and artistic endeavours, this work also appears to be partially incomplete.

Furthermore, in the painting the light appears to be coming from both behind and in front of the window, indicating that Leonardo was already experimenting with the innovative advanced painting techniques he would come to refine in later years.

Leonardo's backdrop
High Renaissance's greatest exponent

The Italian Renaissance is a truly unique period of history that impacted European society in just about every way possible. Leonardo was an extraordinary being who lived in this extraordinary time; it is therefore of little surprise that he soared the heights of cultural and intellectual ability.

As a cultural movement, the Renaissance encompassed a resurgence of learning based on classical sources, the development of linear perspective in painting, and gradual but widespread educational reform. In the world of art, the Renaissance saw an express desire

on the part of artists to combine Roman and Greek classical forms with those of the natural world. They believed this would help them to create realistic paintings that perfectly captured their understanding of pure, untarnished beauty.

These hallmark Renaissance characteristics peaked between around 1490 and 1527 and this period, when Leonardo did much of his work, is often called the High Renaissance as it represents a culmination of the brave new ideas that had developed over the previous years. Unlike the Early Renaissance that centered mostly in the region of Florence, other parts of Italy including Rome and Milan felt the influence of the far-reaching High Renaissance.

By around 1520 the heyday of the High Renaissance had passed. History likes to record itself in discrete segments, and the Renaissance is no exception; the period directly after the High Renaissance was characterized into a somewhat lesser known era known as Mannerism that lasted until around 1580 in Italy. The artists of this Mannerist period took their main inspiration from

Michelangelo and Raphael, and their art is characterized by what can only be described as a hyper-stylization of Renaissance art.

Leonardo's art, which is often viewed today as more classic in its poise and beauty, was quintessentially Renaissance in style and therefore less of an inspiration for Mannerists than that of his contemporaries. The man and his work were true exponents of the so-called High Renaissance period in history.

OTHER HIGH RENAISSANCE ARTISTS
Further to Leonardo da Vinci, other famous artists of the High Renaissance include Michelangelo Buonarroti (1475–1564) and Raphael (1483–1520). Similarly to Leonardo, Michelangelo and Raphael both studied in Florence and worked in painting, architecture and a plethora of other arts.

Hub of Renaissance
The momentous role of Florence

It is impossible to overestimate the momentous role that Leonardo's hometown of Florence played in Italian culture and the development of the Renaissance. Attracted by the financial and cultural dominance to be found here, by the mid-15th century the city had become a haven for talented artists. Indeed by the 1470s it was home to more than 50 stonework shops and close to 30 master painting studios, an unprecedented artistic community.

It was in this supremely cultured environment that the Renaissance really began to gain momentum. The wealthiest Florentines began supporting the humanities and sciences; writing, painting, sculpture and architecture were all disciplines that suddenly found themselves very much in the public eye.

The Florentine Medici was one of the most influential ruling families during this Renaissance period and would emerge to be one of the city's most ardent supporters of the arts. It should come as no surprise then that in time the destiny of this family became intrinsically intertwined with Leonardo's.

The Florentine skyline

Golden oldies
Revival of the classics

Humanism was probably the most dominant cultural movement of the Renaissance period in which Leonardo lived. It is most commonly characterized by a revival of Classical influence and learning, an individualistic and critical spirit, and a shift of emphasis from religious to secular concerns. Renaissance artists such as Leonardo came to admire the structured principles employed by the ancient Greeks and Romans, and the purity of these rules provided a sense of order they sought to emulate in their own work during these tumultuous times.

One of the most attractive elements of this classical revival was the sense of beauty and proportion that it promoted. Classical architecture had used balance and harmony to achieve aesthetic appeal and religious symbolism, and classical temples with ordered layouts and symmetrical columns conveyed a sense of order that Renaissance artists and architects sought to recapture. There was certainly nostalgia at work here, too.

When it came to looking back into antiquity, Renaissance artists adopted the familiar 'grass is always greener on the other side' philosophy. In their view Greek and Roman culture provided a strong role model, little apparent corruption, and the vision of a glorious past.

These were all strong, attractive ideals and Leonardo and his contemporaries embraced them eagerly and fully. The Renaissance Church was, of course, still a powerful influence in the lives of 15th- and 16th-century Italians, and maybe its often corrupt and tumultuous presence stood in stark contrast to the perceived serenity and order of the Classical past.

FIRST SIGNS OF HUMANISM
One of the earliest signs of Humanism is to be found in poetry. Dante (1265–1321) started to study ancient Greek and Roman writings, a significant innovation for his time. In imitating both the style and epic feel of ancient works, Dante started a new tradition that clearly deviated from the Christian scholastic order

predominant at the time. It was a tradition that became immediately popular amongst those who could afford his works – his poetry came to be compared to that of the Classical masters such as Virgil, whose Aeneid was one of the best-known classics of the day.

Economic boom
A Renaissance in trade

The start of the Italian Renaissance marked the restoration of trade in Europe after the comparative dearth of the Middle Age period. Dramatic financial and economic growth was a major factor in the prosperity that supported the growth of art and culture, and economic policies were critical in allowing the growth of the Renaissance. Leonardo and his contemporaries would have undoubtedly felt and benefitted from this extraordinary boom time.

As populations grew and city-states expanded in Italy, trade also increased. The first priority in serving this wealthy population was

Pages from the Gutenberg Bible

to import luxury goods from the Mediterranean to Italian port cities such as Pisa, Genoa and Venice. Situated between Western Europe and the Mediterranean, Italy was ideally located to become a major trade centre and the country's port cities grew large and spectacularly wealthy as trade increased.

Impact on Florence
As trade increased the flow of money through Italy's port cities, other cities with secondary industries such

as banking also started to flourish. Florence, Leonardo's own beloved city, became Italy's central hub of banking in the early 14th century.

This benefitted the prominent Medici family and their extensive chain of banks enormously. The family's substantial profits were subsequently invested liberally in Florence and other Italian cities, vastly enriching the cultural environment through the commission of myriad works of art and architecture.

THE DAILY NEWS

Another landmark innovation, the printing press, had a remarkable effect on the spread of knowledge during the Renaissance. In around 1455 the printing of Johannes Gutenberg's famous Gutenberg Bible *served as an early example of the possibilities of movable type for the dissemination of knowledge and culture. While Germany took an early lead in printing, Italy soon embraced the challenge, establishing presses that printed affordable copies of classical texts and other works. Suddenly knowledge was easy to spread and Italians could afford to buy printed*

books instead of expensive hand-copied volumes. Leonardo, amongst many others, took advantage of this innovation and gleaned much of his knowledge in his earliest years from the volumes of printed books to be found in his family and friends' flourishing libraries.

Find a sponsor
Earning an artist's daily bread

The extraordinary cultural revival of the Renaissance period meant that artists became prominent, respected members of society. Patronage was the principal method by which an artist could earn a living whilst devoting himself wholeheartedly to creating art, and Leonardo's patrons played a critical role in his basic survival and growth as one of the world's greatest artists.

A patron was essentially a person who gave financial, or other support, to an artist. In some cases, a wealthy individual would bring an artist into his home, providing food and shelter in exchange for masterpieces. Alternatively, a person

or group would commission a particular work of art and the artist would be employed until the work's completion. Those who could afford fine art chose to support the masters who created it, and in return were able to surround themselves with the most amazing works of the period.

Leonardo's experience was no different to any other artist of the time; it was essential that he found and worked for a patron in order to earn his daily bread. As it turned out, many different patrons sponsored Leonardo over the course of his life, all of whom were strategically placed as highly prominent political figures.

The relationship between patron and artist was usually formal. Most of the time a contract was involved, requiring the artist to create a specified number of works for an agreed sum. Generally, when artist and patron argued it was over money. In Leonardo's case, there were also plenty of arguments over his inability to complete projects, and the style or content of a particular work were certainly known to spark disagreements. While in most cases the relationship was likely terminated

for reasons beyond his control, it's also possible that Leonardo ended some of the relationships on his own.

MEN ONLY

Virtually all Renaissance's artists under patronage were men. Women were not encouraged in the arts during this period, largely because the study of nudes was a part of every artist's training and it was considered socially inappropriate for women to partake in this activity. While uncommon, there were still a few female artists working in the Renaissance. One was Caterina van Hemessen (1527–1566), a Flemish painter who was the daughter of well-known Renaissance artist Jan Sanders van Hemessen. Caterina had the good fortune of being able to learn and study in her father's art studio, and she actually earned her own patronage from Maria of Austria. Once married in 1554 though, her painting career came to an abrupt end. Another exception was Marietta Tintoretto (1560–1590), daughter of the famous Venetian painter Jacopo Tintoretto. Her father's status guaranteed her a solid artistic

education, and her works were so impressive that she was actually solicited to be court painter for Phillip II of Spain. As it turned out, her father urged her to stay at home and she chose to follow his wishes. 'La Tintoretto', as she was called, died in childbirth at the tender age of 30 years old, her contribution to the art world also cut sadly short.

A-list patronage
Early dealings with the Medici

In Renaissance Florence the Medici were unquestionably the most important political family. The richest family in Italy, perhaps in Europe, they spent breathtaking amounts of money building churches, supporting art, donating to charity, and constructing family monuments to ensure their continued political and social dominance. Thanks to this family's avid patronage of the arts, Florence had risen to a dominant and esteemed position in the Renaissance world of art. And as a prominent artist residing in Florence, it was inevitable that Leonardo would have dealings

with this family at some point.

During Leonardo's lifetime Lorenzo de' Medici, also known as Lorenzo the Magnificent, ruled the family and Florence. By 1480 Leonardo had struck out on his own and established his own studio in Florence, yet was struggling to pay bills and meet deadlines – the only answer was to find a patron. He therefore came under the patronage of Lorenzo de' Medici along with many other fine Florentine

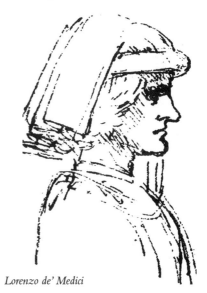

Lorenzo de' Medici

artists, including the notorious Michelangelo.

Unfortunately, this particular patron-artist arrangement did not last for long; Leonardo was a strong-spirited artist with a reputation for not finishing everything he started, and Lorenzo the Magnificent expected his sponsored works to be completed on time. This resulted in an uneasy relationship and, after a few years, it became time for Leonardo to move on.

ADORATION

During the time Leonardo was under the patronage of Lorenzo, the artist was commissioned to paint Adoration of the Magi *for the monastery altar of San Donato Scopeto in Florence. The painting shows the Three Kings along with Mary and her infant son. Although Leonardo was given more than two years to complete this piece, even that wasn't enough time. He managed to finish enough of it however to demonstrate that he was well on his way to breaking from his former master Verrocchio's influence. The style differs from previous works, with a triangular grouping of people in the foreground and an elaborate background that combines natural and architectural elements.* Adoration *has a balanced, symmetrical structure, showcasing Leonardo's rapidly developing independence.*

Militant Sforza
A fruitful period with the Duke of Milan

In 1482 Leonardo applied for patronage with the soon-to-be Duke of Milan, Ludovico Sforza, and subsequently filled the position of the Duke's court painter. This was to be a remarkably happy arrangement that lasted for an astounding 17 years, until 1499. Under Sforza's partronage Leonardo truly came of artistic age and completed two of his finest works, at the same time finding the opportunity to experiment in sculpture, weapon design, architecture and machinery.

Similarly to the Medici in Florence, the Sforza family was dominant in Milan at this time. However unlike

the banking Medici, the Sforza were predominantly warriors, some even employed as *condottierei* or mercenary soldiers who fought in wars for the highest bidder. The Sforza rose through the military classes over time, eventually gaining control over Milan from around 1450 to 1535.

Ludovico Sforza became Duke of Milan in 1494, and while spending much time embroiled in political turmoil, he made a point of investing in the arts and especially in Leonardo. When applying for the job with Sforza, Leonardo wrote a detailed list of his engineering and military credentials, with his artistic skills listed as almost an afterthought. Fortunately, Sforza recognized and took advantage of all Leonardo's talents.

Prolific output

Appointed as the Duke's chief military engineer, Leonardo invented several war machines and weapons during this period. He also began the habit of saving all his designs and notes in copious notebooks; these books providing the basis for almost all our information about Leonardo's unrealized designs and innovations.

Beyond his military inventions, Leonardo created two of his most famous paintings whilst under the patronage of this militant duke. He started *The Virgin of the Rocks* in 1483, a painting intended for the altar at the Chapel of the Immacolata in the Milanese church of San Francesco Grande. The contract was specific yet the notoriously individualistic

Ludovico Sforza, Duke of Milan

Leonardo decided he wished to complete the project his own way. He swiftly ran into problems that resulted in a lengthy, infamous lawsuit.

Also during this period, Leonardo began to work on another of his most famous paintings, *The Last Supper*. Commissioned by Ludovico himself, this work was to be painted on the refectory wall of the family chapel, namely the church of Santa Maria delle Grazie in Milan. The giant mural was almost 9m (30ft) long and was, amazingly, completed. However it began to deteriorate almost immediately, most likely due to the type of paint Leonardo used and the extreme humidity of the refectory's walls. Many attempts were made to restore it over time, culminating with a painstaking effort that was completed in 1999.

Infamous Borgia
His genius turns lethal

One of the Renaissance's more notorious political figures was Cesare Borgia, Duke of Valencia, who lived from 1476 to 1507. Born out of wedlock, he was the son of Pope

Alexander VI. Initially, Cesare set out to become a cleric and became Archbishop of Valencia while his father was traveling down the road to papacy. However despite his role as a man of the cloth, much of Cesare's life was spent battling for control of various Italian city-states.

By the early 1500s Cesare ruled territory throughout Italy, at least part of which he had taken by force. When his father died in 1503, Cesare attempted to garner a religious position in Italy but his power slowly waned, his lands were overtaken, and his castles fell into his enemies' hands. He was imprisoned on several occasions and, in a fitting end to a life of abject terror, he was slain whilst attempting to lay siege to a castle in the year of 1507.

Needless to say, Cesare's infamy guaranteed him a place in history. Renaissance writer and philosopher Niccolo Machiavelli (1469–1527) may even have based *The Prince*, his political examination of the rulers of the day, on the life of this warlord. Cesare's contemporary influence was enormous and undeniable.

Turning lethal

As with so many religious and political figures of the day Cesare was a patron of the arts, and Leonardo joined him in the early 1500s, remaining in his patronage until the artist returned to Milan in 1506. The military experience he had previously gained whilst working with the Duke of Milan helped him to secure the position with Cesare's army and he was quickly put to work designing war machines.

During his time with Borgia, Leonardo designed a stunning range of lethal machines and weapons including collapsible bridges, wall-mounted ladders, rotating scythe blades attached to moving chariots, catapults, crossbows, machine guns, and cannons. Leonardo's genius was more than capable of turning lethal, when required.

A VIOLENT REPUTATION

Cesare Borgia is infamous for supposedly having killed his own brother Giovanni in 1497. There is no conclusive evidence for this, although Cesare was said to have been jealous of his brother's high social position and may have also fought with him over a woman. Nevertheless, he had a violent reputation and was likely responsible for various murders over the course of his lifetime.

Cesare Borgia

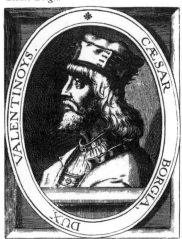

Father of the people
Head hunted for the position of court painter

King Louis XII of France (1462–1515), affectionately dubbed 'Father of the People', was a popular king with major influence during the Renaissance. At that time many powerful French leaders of the day asserted claims to dominance in Italy and Louis was part of this movement. Shortly after his coronation in 1498 he invaded Milan where he remained in power until 1513.

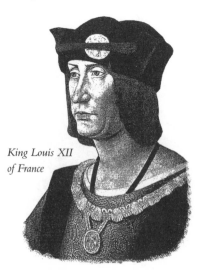

King Louis XII of France

After his time as Cesare Borgia's military engineer, Leonardo had returned to Milan in 1506. He was becoming increasingly renowned, and he was subsequently head hunted by King Louis' governor, Charles D'Amboise, for the position of Louis' court painter. Employed not just for painting, Leonardo also provided architectural, military and other engineering expertise to King Louis.

Leonardo painted several masterpieces during this period. In 1506 he worked on a version of *The Virgin of the Rocks*; in 1509 he painted the now lost *Leda and the Swan* and *The Virgin and Child with St Anne*; and in 1510 he started working on *St John in the Wilderness*. Leonardo also used this time to engage in some enjoyable independent study, indulging his fascination for botany, hydraulics, mechanics and other sciences, and in 1512 he produced one of his first self-portraits.

Leonardo remained Louis XII's court painter until the king was forced from Milan in 1513. At this point, Leonardo left Milan and found work in Florence and Rome over the following several years.

An exalted position
Reconciliation with the Medici

Giuliano de Medici

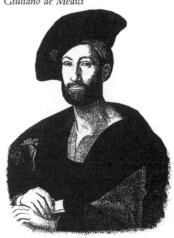

Giovanni de' Medici, son of Lorenzo the Magnificent, enjoyed a meteoric rise to become Pope Leo X. Giovanni's brother Giuliano also commanded an distinguished position as head of the papal army. Art historians are particularly fascinated with Giuliano because he served as Leonardo's patron from 1513 to 1516.

After King Louis XII of France was forced out of power in Milan in 1513, Leonardo was freed from his role as court painter and swiftly (and wisely) machinated reconciliation with the Medici family. He moved to Rome and remarkably took up residence in the Vatican with his new Medici patrons, where he earned the respect of both religious authorities and other artists. He ran his own workshop and took on many commissions under the direction of both Giuliano and the Pope.

This exalted position provided Leonardo with luxuries that other artists simply didn't have; he found he had large amounts of free time to study and focused his efforts on learning more about anatomy and physiology. It was during the course of these studies that Leonardo became convinced of the scientific importance of dissecting human cadavers, a conviction consistent with other Renaissance scholars. However to Leonardo's dismay the Pope issued orders expressly forbidding the dissection of human bodies. Faced with no other choice but to obey the powerful brother of his patron, Leonardo reluctantly obeyed and relinquished these studies for a time.

Leonardo created several masterpieces while under Giuliano de' Medici's patronage. One of his crowning achievements was *St John the Baptist* – completed in 1516, this may be the last painting Leonardo ever worked on. This painting is particularly significant because it clearly demonstrates *sfumato*, Leonardo's innovative technique to make people and objects appear to dissolve into one another and the background.

WHEN ILLNESS FALLS
Between 1513 and 1516, whilst working for his patron Guiliano de' Medici in Rome, Leonardo became seriously ill and his productivity fell dramatically. It was said to have been an incredibly frustrating time for the great master and his notebooks clearly reveal this anger and frustration. A letter to Giuliano in 1513 indicates that both Leonardo and his patron were suffering from illness at this time, and that while Leonardo was pleased that his patron's health was improving, he wished he could have hastened his own recovery. Perhaps it was this precarious physical situation that finally drove Leonardo to accept what was essentially retirement at the French court of King François I.

François the friend
Last days in the lap of luxury

From 1516 to until his death in 1519, Leonardo worked at the court of François I, King of France (1494–1547). François was crowned in 1515 after inheriting the crown from Louis XII. Often considered to be the first true Renaissance king, François was enchanted with the art of the day. His mother and early tutors steered the young François toward the arts and humanities, and he reportedly invited Leonardo to visit the French court and ultimately convinced him to stay. Once there, Leonardo was fantastically honoured and respected, and rather than simply being known as court painter he was given the prestigious title of Premier Architect, Engineer and Painter.

While some of his earlier accommodations were little more than stable rooms, Leonardo's final home was a luxurious manor house

close to the French royal palace, namely the Clos Luce Manor in the Loire Valley. This free room and board wasn't all – Leonardo was extremely well paid for his work during these final years, and was reputedly closer to François than any of his previous patrons. Apparently the king did not ask Leonardo to produce much work towards the end of his life – the artist's primary role was to serve as the king's friend. It was even rumoured that there was an underground passage between the Manor and royal palace to provide the king easy access to the bedside of his aging companion.

Towards the end of his life Leonardo spent much time sketching. He continued drawing subjects from his earlier years, including animals, plant life and water. Notably during this period he developed some of his first sketches of water flowing freely and circulating in a whirlpool. Later, scientists researching turbulence would study these drawings as inspiration for their own innovations. Leonardo also used this time to develop preliminary designs for scuba gear, diving suits, movable bridges, underwater craft, and many other

devices that became the forerunners of designs to come.

A SPECIAL GIFT

By all accounts François had a special place in his heart for Leonardo, and the feeling appears to have been mutual. Leonardo's favourite work was the **Mona Lisa** *and he kept this painting with him at all times until, as evidence suggests, he either gave or sold his beloved treasure to King François near the end of his life.*

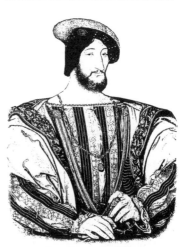

King François I of France

Gold medal standards
Innovations towards realism

Renaissance art paid homage to its Greek and Roman ancestors, but at the same time forged its own distinct path. Different methods of artistic representation were developed during the 15th and 16th centuries, and Leonardo popularized several of them, establishing astonishing gold medal standards that would be emulated in art forever more.

Essentially Leonardo sought to paint more realistically than his predecessors. To achieve this realism, it was necessary for him to adopt

and develop the new techniques that became his key artistic innovations.

Linear perspective

Perhaps the best-known innovation in Renaissance art was linear perspective. Perspective is a method of drawing objects realistically with relative distances between them, so objects closer to the eye look larger than those further away. Early Renaissance architects such as Fillipo Brunelleschi (1377–1446) and Leone Batista Alberti (1404–1472) developed linear perspective techniques, and Leonardo became a major proponent of this new drawing method. So while he certainly didn't invent it, he did

Perspective sketch of Adoration of the Magi

use it to such an extent that other artists soon came to admire, and then imitate, his outstanding style that relied so heavily upon this innovation.

Chiaroscuro

Historians largely credit Leonardo with developing the critical artistic innovation known as *chiaroscuro*. Translated from Latin, this means *chiaro* or 'clear, bright', and *oscuro* or 'dark, obscure'. Here Leonardo used light and dark tones, depending on the direction in which the light fell in the painting, to create the illusion of a three-dimensional solid form. This use of the *chiaroscuro* technique represented the first time a Renaissance painter had contrasted lights and darks to create a truly three-dimensional image.

Chiaroscuro is evident in many of Leonardo's paintings, including the early *Benois Madonna* of 1478. Over the centuries Leonardo's *chiaroscuro* technique has become so integral to artistic training that some historians have identified it as one of Leonardo's most important artistic contributions. While initially developed by Leonardo, the technique of *chiaroscuro*

was more fully developed and utilized in later periods. Indeed during the 16th century, Mannerist and Baroque artists took full advantage of this fledgling technique.

Sfumato

In addition to representing lights and shadows accurately to create the illusion of reality, Leonardo needed his paintings to convey subtle transitions from one tone to another. *Sfumato*, an Italian word meaning 'vanished,' is used to describe a technique Leonardo developed to do exactly that; subtly blend and graduate tones between parts of an object to accurately reflect the object's roundness. Layers of paint were combined, often with almost indecipherable differences in tone, to create a three-dimensional image that looked as real as the subject. Leonardo used this effect to make his paintings not just mimic reality, but to actually become real – or as real as a painting can be.

A FINE EXAMPLE
The Mona Lisa *is a striking example of the* sfumato *technique. While the model's face is enveloped*

by shade and shadow, it is also completely smooth. Leonardo used brushes and his fingers to blend the tones and create perfect transitions to represent the light as it swept around the subject's head. Then, the light in the scene simply subsides into darkness. The transitions between light and dark here are imperceptible, the superb blending allowing viewers to focus on the painted subject rather than the technique that created it.

Scene behind the scene
Another intriguing layer to his work

The backgrounds of Leonardo's paintings add another intriguing layer to his work. Inspired by, but moving far beyond, the classical art of ancient Greece and Rome, Renaissance painters developed a new way of combining religious devotion with the new tradition of naturalistic art to place religious scenes or even portraits

Ponte Buriano bridge, whcih was used as a location in the Mona Lisa.

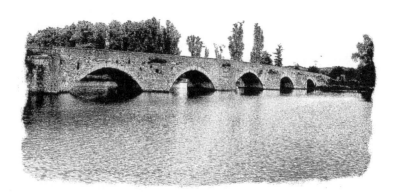

into natural surroundings. Many of Leonardo's paintings were religious, and the Renaissance's influence gave Leonardo the opportunity to incorporate his fondness for the natural world into his predominantly Christian subject matter.

However what is fascinating is that Leonardo took this developing Renaissance methodology to a whole new level. Many of his works use fantastic landscapes as backdrops, sometimes combining complex architectural creations or landscapes with natural elements such as rolling hills, valleys, streams and mountains. Yet even these more natural elements take on an air of the ethereal thanks to Leonardo's innovative techniques. His concept was to render scenes as if they appeared through a fine veil of mist and his technique, *sfumato*, is clearly visible in his earliest remaining landscape drawing, created in 1473 when Leonardo was only 21 years of age.

FANTASTICAL MASTERPIECES
Perhaps the most famous of Leonardo's background landscapes is that of the Mona Lisa. *Rather than painting an indoor backdrop as was typical for portraits, Leonardo positioned Lisa, the lady with the enigmatic smile, in front of a dreamlike landscape full of craggy mountains and sinuous streams. The background perfectly captures Leonardo's view of the natural world, one that is ever-changing and constantly in motion. The only man-made element in this background is a small bridge crossing one of the rivers. On closer inspection it's even more intriguing to discover that the two sides do not match up; the horizon on the right side of Lisa is significantly higher than that on the left side. Most likely, this was a deliberate trick on Leonardo's part to lend an increased sense of activity and realism to the central figure by making her position appear to change depending on whether you viewed her from the left side or from the right. A later painting* St John in the Wilderness, *attributed to Leonardo although not fully confirmed as his, takes one step further than its predecessor. It combines a realistic, natural setting of trees, roots, cliffs*

and animals with one of Leonardo's traditional misty backgrounds. Towards the top left of the painting, the landscape recedes into surreal mists and lakes.

Fine art of completion
An annoying tendency towards bad habits

While Leonardo's supreme genius remains unchallenged, it sometimes seems strange that he is so celebrated as an artist when so few of his paintings remain unfinished. It is hard to pinpoint the exact reason for Leonardo's rather annoying tendency to start a plethora of paintings, but to actually finish very few. It is possible that, as stunning as his works were, they simply did not match the perfection of his initial vision, so he gave up rather than fail in accomplishing his imagined perfection. Another possibility is that, especially later in life, Leonardo saw himself more as an inventor and scientist than as an artist, thus devoting more of his time to such subjects.

The failure of innovation was

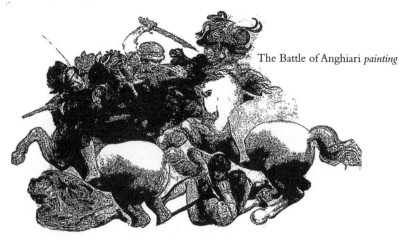

The Battle of Anghiari *painting*

one valid reason for Leonardo's failure to complete work, and *The Battle of Anghiari* is a fine example of this. The project was to depict an entire battle scene on a wall in the Florentine Plazzo Vecchio, directly opposite another new work by none other than the great Michelangelo. When Leonardo painted the piece using an experimental technique the paint adhered to the walls without problem. Tragically, when Leonardo applied heat to dry and fix the paint, disaster struck. Some of the paint ran from the walls and the rest scaled off in pieces. The project was close to a complete failure, and other artists lamentably ended up painting over Leonardo's original work.

Beyond his penchant for experiments that occasionally backfired, his lack of completion may also be attributed to the fact that Leonardo simply got bored. He may well have worked first and most intensely on the aspects of a painting he found most interesting, and simply left other parts incomplete or commissioned his students to complete them instead.

Not finishing what he started

got Leonardo into hot water on more than one occasion. In some cases patrons never paid him for his unfinished work; in others, he had to return the initial advance he had received when he didn't complete a commission on time. An infamous lawsuit with monks over the uncompleted *The Virgin of the Rocks* dragged on for an astounding ten years.

Architecture of the imagination
A bold step in the opposite direction

L eonardo was renowned for the realism he brought to so much of his work. It is therefore fascinating to discover that he often painted scenes with extraordinary architectural elements that had more in common with flights of fantasy than with anything rooted in reality. *The Adoration of the Magi* of 1481 is one of the best examples of this. Commissioned for the monastery at San Donato Scopeto in Florence, Leonardo worked on this scene during the years spent under the

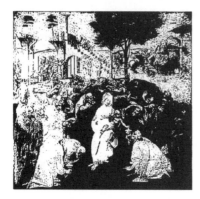

Adoration of the Magi painting

patronage of Lorenzo de' Medici and it was the first work he created largely on his own. While the painting focused on Mary, baby Jesus and the three Magi, the scene also contained about 60 other people, a variety of animals and other natural elements.

Although Leonardo never finished this painting (this should come as no surprise), it is clear that the scene contains architectural elements that are at least partially more imaginary than real. For example the unusual staircase in the background could be part of a medieval castle, or it could belong to the ruins of a Roman imperial palace. Either way,

the feature seems completely out of place in this scene set in lush countryside.

The painting is nothing more or less than a fanciful composition. Its early sketches were even more extreme, showing animals in different perspectives and poses. Some sketches had parts of the stairs dating from a different period and age, while others were even composed of different materials. There are multiple points of perspective, and the painting almost appears more like a collage than one coherent work. It could almost be described as a motley collection of painting elements; at the same time it would probably be fair to say that Leonardo loved working on every minute of it.

IMPORTANT MILESTONE

The details in Adoration of the Magi *mark an important milestone in Leonardo's career. As a true Renaissance painter, he focused on finding ways to represent humans, animals and nature more accurately through the medium of painting, and his innovations in painting such*

as chiaroscuro *and* sfumato *were a means toward that end. Fantasy elements, on the other hand, take a step away from reality. Perhaps Leonardo's playful side came to the fore through these sorts of details, or maybe they afforded Leonardo the opportunity to contrast his new skills against a more whimsical background. Whatever the reason, the fanciful architecture incorporated within Leonardo's paintings increases the depth of his work and speaks to both his inherent creativity and his willingness to take risks.*

young mistress of Ludovico Sforza, Duke of Milan. Often identified as the first modern portrait, this work differs significantly from established portrait painting styles in the 15th century.

Firstly, Leonardo posed Cecilia in three-quarter view, rather than in the strict profile view favoured at the time. There is also an added sense of motion inherent in this scene as the subject twists her head and upper body, fixing her gaze on something outside the field of view. The warm lighting

It's all in the detail
The first modern portrait artist

It should come as no surprise that Leonardo had a remarkable ability for painting portraits. His particular strength was in capturing the facial expressions of his sitters, a skill clearly evident in even his early works.

Lady with an Ermine

Lady with an Ermine was painted around 1490 (or perhaps earlier) and is a portrait of Cecilia Gallerani, the

Lady with
an Ermine
painting

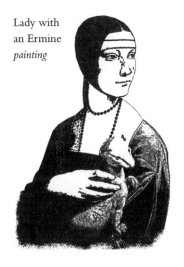

in the image is a means to provide a three-dimensional impression that is almost sculptural in effect, and the painting also depicts the detailed embroidery and ribbons on Cecilia's gown with painstaking and unprecedented precision.

Leonardo's knowledge of anatomy and nature allowed him to capture both the beauty and the intelligence of the young lady, and to create a realistic portrayal of the ermine. The beauty of Cecilia's face, and her enigmatic half-smile, evokes a later, sensationally famous portrait, namely the *Mona Lisa*. Leonardo initiated a portrait trend with *Lady with an Ermine* that set the stage for further exploration and development.

Other famous faces

Lady with an Ermine also boasted marked differences when compared to other early Leonardo paintings. For example, one of his other famous faces is found in his *Portrait of Ginevra de' Benci*. This painting could date to as early as 1474, when Leonardo was still working with his master Verrocchio. It includes some elements typical of Leonardo's style, such as

a mystical backdrop and detailed background rendering, and it also shows botanical elements such as the juniper bush.

However the portrait itself is much flatter and has none of the three-dimensionality of *Lady with an Ermine* or other later works. Moreover, the subject has a brooding, almost sulky expression, and her face certainly doesn't have that familiar mysterious and enticing smile.

Lengthy lawsuits
Veering from the brief on The Virgin of the Rocks

Unbelievably, the commission of this quintessential Renaissance painting that depicts the Immaculate Conception initiated an extraordinarily lengthy lawsuit. In fact the project was actually done twice because of the infamous furore that took place around it, and the whole episode provides a fascinating insight into Leonardo's artistic dealings.

The chapel of the Immaculata at the Milanese Church of San Francesco Grande originally commissioned *The Virgin of the Rocks*

in 1483 as an altarpiece. The original contract for the work was remarkably specific: the commissioning monks wished the Virgin to be the painting's central focus, with prototypical Greek angels flanking her. Their brief even specified the robe colours for the Virgin and angels. Despite these specifics Leonardo, in his very own inimitable style, decided to take a measure of artistic license and exchanged one of the angels for St

The Virgin of the Rocks *painting*

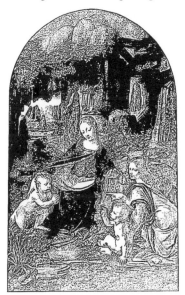

John. It seems that the one consistent element in the artist's career was that he always had to assert his personal style in each of his projects.

The Virgin of the Rocks could not be categorized as a rush job, but the contract length was relatively short leaving Leonardo only eight months to complete the entire painting. Predictably, Leonardo ran into trouble finishing the painting on schedule, and the work became the subject of a lengthy lawsuit. In addition to the missed deadline, Leonardo apparently entered into a dispute with the monks about the financials of the commission. Leonardo complained to the monks that not only had he not received full payment, but also that the initial amount negotiated for the entire work had in fact barely covered the cost of the frame.

Resolution

Disputes and lawsuits over time and money continued for many years. Eventually, the monks deemed the first version of the work incomplete, thus forfeiting the rest of the money and granting Leonardo ownership of the painting. It is thought that

Leonardo gave this version as a gift to King Louis XII of France who helped resolve the lawsuit, and it now hangs in the Louvre.

Leonardo subsequently renegotiated the contract with the monks, who agreed to pay for a second version of the work in 1506. The monks gave Leonardo two years to complete this second painting, paying half the amount negotiated for the original work. This version was in fact finished on time and finally hung in the chapel on 18 August 1508 where it remained until 1781, when it passed through the hands of a number of collectors until eventually coming to rest in the National Gallery of London.

SPOT THE DIFFERENCE
Leonardo painted two iterations of The Virgin *of the* Rocks, *and the later reiteration contains a few significant changes from the original version of Leonardo's masterpiece. The colours are brighter and bluer, the angel on the right is no longer pointing at St John (who is now holding a cross), and halos have been added above the Virgin Mary and one of the angels.*

A chapter of accidents
Ill-fated life and times of The Last Supper

One of Leonardo's signature paintings *The Last Supper* is notably also one of his most accident-prone and least well preserved. Leonardo completed this prodigious mural in 1498, the piece depicting the moment at which Jesus discloses that one of his disciples will betray him.

Ludovico Sforza, Leonardo's patron at the time, commissioned the painting. Ludovico had chosen the Church of Santa Maria delle Grazie to become his family chapel, and Leonardo was hired to paint this immense mural of the Last Supper on one wall of the chapel's refectory. Although the work was to be done on a grand scale Leonardo was not in the least daunted – he completed *The Last Supper*, certainly one of his greatest masterpieces, in just three years. This time scale seems especially miraculous when compared to many of Leonardo's other projects which were either never completed or dragged on for many years, and this speedy execution surely points to the

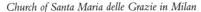

Church of Santa Maria delle Grazie in Milan

depth of concentration Leonardo put into the project.

Degradation and destruction

Unfortunately *The Last Supper* began to deteriorate almost as soon as it was finished, primarily due to Leonardo's love of innovation. Instead of using the usual method of fresco painting in which paint was applied to a wall of fresh, wet plaster, Leonardo designed a new method where he applied paint directly to dry plaster. Using this new method he was able to work more slowly and methodically than on wet plaster, and was able to paint with a wider variety of colours. And that's where the good news ends. This method proved unstable, and the paint began flaking off the wall during Leonardo's lifetime, the room's humidity and the moisture in the wall upon which *The Last Supper* was painted further exacerbating this deterioration.

By 1586 the masterpiece had degraded to such an extent that it was barely visible. Over the centuries, a number of restoration attempts have been made. Regrettably these

methods often caused more harm than good, or involved so much over-painting that little of Leonardo's original masterpiece remains. The work also suffered from more practical concerns in the church. At one point workers cut a door opening through the bottom of the image, at the expense of Christ's feet that were removed as a result. And in 1796, Napoleon's troops used the room containing the painting as a stable of all things. After that, *The Last Supper* had yet more disasters to endure; a flood in 1800 left it covered in a layer of green mould, and Allied bombing in 1943 blew the entire ceiling off the church rectory.

Attempted salvage

Given this tumultuous history, it is surprising that anything is left of *The Last Supper* at all. An initial restoration was completed in 1954, and finally a 22-year-long restoration project was completed in 1999. The restoration attempted to reveal Leonardo's original intent and was truly painstaking, requiring restorers to re-attach tiny flakes of the original paint in the original locations.

Sadly parts of the ill-fated work are beyond repair, including the facial expressions of the Apostles. However a number of copies do exist, some dating from before the deterioration had become problematic, and if compared to the currently restored version one can only imagine how spectacular the original would once have been.

That enigmatic smile
Lasting resonance of the
Mona Lisa

Most people recognize the *Mona Lisa* – it's the painting for which Leonardo da Vinci is perhaps most famous and it is also, arguably, the most famous portrait painting in the world.

The sitter was most likely the wife of Francesco del Giocondo, a silk merchant in the late 15th century. He was involved with the government in Florence, and he and his wife Lisa were probably married in around 1495. So what is it about this particular work that has created such a lasting impact on the world?

Face value

The expression on this Florentine woman's face is without doubt one of the painting's most exceptional, and memorable, features. Her simple, dark clothing sharply focuses the eye on her face and her smile appears to be at once both innocent and enticing. One account describes how Leonardo hired musicians and mime artists to amuse Lisa during the extraordinarily long sitting that lasted for an incredible three years.

Also significant about the model's expression is that one eye is positioned slightly higher than the other, adding to a sense of movement in the painting. Viewers of the original frequently comment on how these eyes seem to follow them around the room. Leonardo probably created this effect on purpose; the corners of the mouth and eyes are the most expressive parts of the human face, and Leonardo did not over-define them in this painting. Instead they are highly shadowed and almost vague, causing Lisa's expression to appear to change depending on the viewer's perspective.

Although women of the day usually had portraits painted while they were dressed in their finest, Lisa is dressed simply with no elaborate jewellery or a fancy dress. One theory behind the sitter's everyday outfit is that Leonardo didn't want to detract from the pure lines he was creating; as it is, her simple, dark clothing makes her face the complete, undisputed focus of the painting.

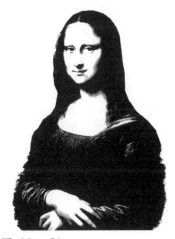

The Mona Lisa

ON THE ROAD
Like Leonardo himself, the **Mona Lisa** *has done plenty of travelling.* **Leonardo carried the painting with**

him to France during his time with King François I and at the end of his life he either gave or sold the painting to the King. It subsequently found its way to the Louvre, a fitting home for this extraordinary masterpiece. Napoleon borrowed the painting for a period, and it was hidden during the Franco-Prussian War to protect it from damage. In 1911 a Louvre employee named Vincenzo Peruggia stole the painting and tried to sell it, but he was eventually captured and the artwork was returned to the Louvre in 1913. The Mona Lisa *was hidden again during World Wars I and II then, during the 1960s and 1970s, it toured various countries. Regrettably, due to understandable and wise security concerns, it seems unlikely that it will leave the Louvre again any time soon. At present it resides in the museum behind bulletproof glass in a climate-controlled enclosure.*

The riddler
Puns and symbolism in his paintings

Leonardo had a notoriously witty intellect and a passion for secrecy, and he loved nothing more than to bury riddles in the form of puns and symbolism amongst the folds of his work. Leonardo seems to have been particularly fond of puns, and many of his paintings include puns on the name of the person being painted.

Ginevra de' Benci *painting*

One of his earliest known paintings *Ginevra de' Benci* is a portrait of a young woman that was probably painted to celebrate her marriage. The woman is posed in front of a large juniper plant, a symbol of chastity and therefore appropriate fare for a marriage portrait. Yet Leonardo has sneakily included another reference here – the word for juniper in Italian is *ginevra*, so the presence of a juniper plant in the painting is also a pun on the young lady's name.

Another of Leonardo's early paintings *Lady with the Ermine* contains a similar pun. The woman in the painting is thought to be Cecilia Gallerani, a mistress of Leonardo's patron at the time, Ludovico Sforza, Duke of Milan. The ermine that the young lady holds was a symbol of Sforza's court and appeared on his coat of arms, thus a logical choice to appear in the painting. Moreover the Greek name for ermine is *galee*, which makes the animal's inclusion another clever pun on the young lady's name. However, the addition of an ermine into Leonardo's famous painting has even further subtle underpinnings that reveal Leonardo's

sense of humour. An ermine with its pure white coat was considered a symbol of chastity, making the animal a somewhat ironic choice for the portrait of the Duke's mistress.

Symbolism was also common in Leonardo's works. In his time objects such as carnations or lambs bore strong religious significance. Leonardo's early work *Madonna with the Carnation* shows Mary holding a carnation out for the infant Jesus. The inclusion of a flower might seem odd until you know that the carnation was actually a symbol of the Passion – then its inclusion makes perfect sense. Perhaps most obviously, the infant in *The Virgin and Child with St Anne* is embracing a lamb, an eternal symbol of Jesus as the Lamb of God.

SELF PORTRAIT?

Leonardo's most famous work, the Mona Lisa, *is full of symbolism. The veil that Lisa wears could symbolize widowhood; it could also symbolize chastity that would have been appropriate for a married woman. The winding path shown in the background could be the 'path of virtue' popularized in a myth about*

Hercules, and if so would indicate that Lisa was most likely a wife, not a mistress. It has even been suggested that the Mona Lisa is actually a self-portrait of Leonardo as a woman.

On his high horse
The vision for his own personal colossus

Leonardo was well versed in sculpture, and here too he was able to make a significant mark. In 1483 Leonardo set about creating the largest outdoor statue the world had ever seen. This truly grand project was begun in honour of Francesco Sforza, father of Leonardo's patron Ludovico Sforza, and would feature Francesco mounted on a steed. Entitled *Statue of Francesco Sforza,* this work would have been simply enormous, measuring more than 8m (25ft) high.

Leonardo's design went through several iterations; one notable stage featured the horse rearing. This would have undoubtedly contributed a highly dramatic effect to the scene, as well as creating a ridiculously tall statue to honour the Sforza family.

As it turned out though, this idea was technically unfeasible. Leonardo would have had to design an entire structural system for the statue, and a complex one at that. Historians who have studied Leonardo's designs in present times have concluded that, even with the use of modern techniques, it still might not be possible to cast something so large supported at only two points.

While Leonardo had created many sketches and variations of the design by the early 1490s, he still hadn't built an actual statue – accordingly the mighty Sforzas were becoming impatient. To appease his powerful patrons Leonardo quickly created a full-scale clay model. As it happened this became hugely popular and was set up in the garden of the Palazzo Vecchio – people traveled from far and wide to see this enormous masterpiece they affectionately dubbed *Il Colosso.* The clay model naturally did wonders for Leonardo's reputation, as he became known throughout Italy as the exceptional artist who'd created this truly breathtaking tribute to the great Sforza family.

The final bronze statue should have been one of Leonardo's crowning achievements, yet he never completed it. Indeed it is not even certain that Leonardo really could have built it, as there was no precedent at the time for casting a hollow-shell statue on such a large scale. As it turned out, Leonardo and his workshop were in the middle of obtaining bronze – no small task for a statue that would have weighed more than 56 metric tons – when war intervened. France invaded Milan, and the bronze tipped for Leonardo's statue was instead seconded for military equipment.

To add insult to injury, Leonardo's treasured clay model for the Sforza statue didn't survive the war. As the French encroached on Milan in 1499, their soldiers set up outposts near the Palazzo Vecchio and the clay statue was tragically destroyed when the French used it for target practice. The parts that remained slowly degraded over time, and nothing of the original is left today.

Dream becomes reality
Modern-day completion of Leonardo's ambition

One of Leonardo's greatest disappointments may well have been that his massive sculptural design *Statue of Francesco Sforza* was never built. Leonardo's enormous masterpiece would have been the largest equestrian statue on the continent measuring up to 8m (25ft) tall, a truly amazing spectacle by anyone's standards.

500 years after its conception an American airplane pilot named Charles Dent read about Leonardo's unrealized masterpiece in a 1977 *National Geographic* magazine article. Building this equestrian sculpture instantly became Dent's obsession to honour both Leonardo da Vinci and Milan, and he vowed to donate the sculpture he would create to Italy in honour of Leonardo's achievements.

Dent was an amateur sculptor himself and he quickly set about creating his own scale model of the horse. To fund his project he created Leonardo da Vinci's Horse Inc, a non-profit group dedicated to raising

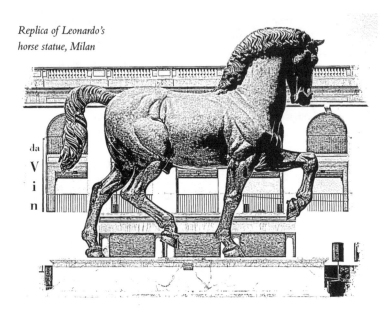

Replica of Leonardo's horse statue, Milan

funds to cast the enormous equestrian statue. On his death in 1994, Dent bequeathed a large amount of money to this foundation – from that point the project took off at a rapid pace.

In due course a reduced size model of the horse was sent to the Tallix Art Foundry in the United States for casting, and was upsized at the foundry to create the 8m (25ft) tall bronze replica of Leonardo's design.

The similarity to the original work was fully retained, and observers commented that the strength, poise and impact of Leonardo's original red–chalk drawings had been successfully preserved.

In deference to Dent's wishes the magnificent sculpture was sent to Milan. It is extraordinary to hear that the giant horse had to be split into seven pieces for safe travel and welded

back together in Italy. Unveiled at a large public ceremony in September 1999, many who had worked on the sculpture were present in Milan for the presentation.

This horse was eventually cast twice, and the Frederik Meijer Botanical Gardens and Sculpture Park bought this second version. The second statue currently resides there in Michigan, USA and is known as the *American Horse*.

Together these sculptures represent an extraordinary tribute to Leonardo and the Milanese people. Italy suffered when the original clay model built by Leonardo had been destroyed by French troops, and Leonardo's own failing to complete this ambitious project probably tarnished his ego – it is supposed that even Michelangelo teased him about his unfinished horse. This 1999 sculpture from the Tallix Art Foundry righted previous wrongs to help bring a sense of completion and closure to Leonardo's legacy.

Crowning glory
Significant plans for the Duomo

During the lengthy period he spent in Milan between 1482 and 1499, Leonardo primarily spent his time working on assignments for his patron Ludovico Sforza, Duke of Milan. This was a marked period of excessive experimentation and output for Leonardo; he produced countless paintings, sketches of military equipment, sculptures, prototypes of machinery and architectural designs. Nonetheless one of his most significant ventures in architecture took place here in 1488, when he created a preliminary design for the dome and tambour of the celebrated Milanese Duomo. Built over a 500-year period, the cathedral was designed to bring the High Gothic style to Milan and work on the cathedral began as early as 1387.

As political and religious power continued to change hands over the years, new designers and masons were invited to work on the cathedral, which would eventually be revered as a living tribute to the outstanding creativity of Italian artists. Political

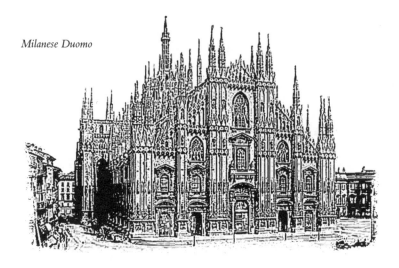

Milanese Duomo

and financial crisis undoubtedly slowed the project, and subsequently the great spire wasn't constructed until the mid-18th century; additional spires and stair towers were built during the 19th century. Regrettably by this point some of the original work was already crumbling. Restoration was necessary, this task eventually occupying much of the early 20th century.

The original chief engineer, Simone da Orsegnigo, created a vision for the cathedral that was maintained across this disparate number of architects, masons, and other craftsmen. During his time in Milan Leonardo was, unsurprisingly, consulted regarding several aspects of the cathedral and he submitted drawings for the dome. Despite the fact it was never built, Leonardo's design was a vital marker in his career. At this point he began to incorporate studies of mathematics, particularly geometry, into his designs, a crucial development that enabled him to view an architectural project in its

entirety. Moreover, the fact that he was approached to design a vital part of such a prestigious national landmark is living proof that he was well respected, even at this early stage in his career.

MULTI TASKING

His work on the Milanese Duomo project reveals Leonardo's famed ability to multi task. He studied many areas simultaneously; in this case all applying to the same project. As well as designs for the dome, Leonardo produced designs for several types of construction equipment and his ideas for cranes were particularly valuable in the completion of the project. He understood the construction difficulties inherent to church domes, and he included sketches of lifting devices with his drawings for the dome.

Moving heaven and earth
Radical plans to move the Baptistery of San Giovanni

His work on this Florentine baptistery, located in what is known today as the Piazza San Giovanni, was a spectacular achievement in Leonardo's career. Created and named for the patron saint of Florence, St John the Baptist or San Giovanni in Italian, this baptistery still has enormous cultural significance for Florentines. In addition to housing a number of sculptural masterpieces, it is rumoured that several famous Italian artists and authors were baptized here including the great Dante. The basic design is an octagonal structure faced with white and green marble, while the most famous aspect of the Baptistery is probably the bronze doors on the eastern side.

Construction began on this building in the 11th century, and by Leonardo's time the project was still very much a work in progress. In the winter of 1507 Leonardo was called to Florence to aid sculptor Giovanni

Francesco Rustici (1474–1554) to create bronze statues of St John, a Pharisee and a Levite that would be located on pedestals above the north doors. Judging from the sculptures' anatomical precision, Leonardo either worked on them himself or at least developed detailed sketches for them.

But Leonardo's work on the Baptistery didn't end there. He later got involved in an extraordinary second round of work developing a scheme for transporting the building. Yes, unbelievably he actually proposed an extraordinary plan to lift and move the entire Baptistery of San Giovanni. He had the idea that elevating the structure to sit upon a marble base would make the church more authoritative and divine. Needless to say, this project would have required a phenomenal feat of engineering and Leonardo's notebooks at the time describe models and preliminary designs for this.

It is not clear whether or not Florence's church and city officials ever solicited this radical undertaking. One thing is for sure, however – during the time Leonardo was in Florence, his notes suggest that he was pressuring the council with increasingly elaborate designs for improving the baptistery. He probably presented this idea to powerful citizens and the board of the baptistery, and he was so persuasive that they may

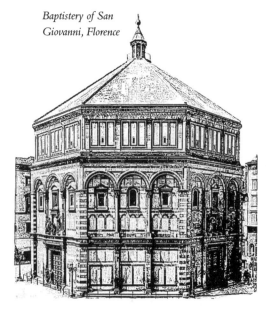

Baptistery of San Giovanni, Florence

have actually considered Leonardo's suggestions. Once Leonardo left Florence though, people quickly realized that his plans weren't feasible. Although modern technology certainly allows engineers to entertain these sorts of possibilities, Leonardo's ambitious scheme was well beyond the capabilities of the day.

Elegant living
Designing to extremes

The majority of Leonardo's architectural designs were for cathedrals or entire cities, but he also worked on some fascinating smaller-scale public projects. Leonardo employed his creative talents to design many public buildings with the specific goal of improving their functionality and enhancing city dwellers' lives. He based his architectural designs predominantly on symmetry and balance, the principles behind much of his work including his religious buildings. Unfortunately, as with his church designs, most of his public buildings were never actually built.

Stables

Leonardo designed to extremes – most of his projects were on a grand scale and filled with elaborate detail. One particularly remarkable design was for a stable with arches and columns supporting a vaulted ceiling – an extremely well designed home for a horse. Designed between 1487 and 1490, the layout for this early project included three lower-level arcades and a number of openings for air circulation.

Horses were vital for both the military of a city and for the general public; Leonardo incorporated these unusual design elements to create a happy, healthy environment for these important beasts. It is interesting to see that along with his designs Leonardo also included notes on how to run a fresh, orderly stable. It is evident from this that Leonardo had immense respect for all living creatures, and believed that animals deserved as clean and elegant a living space as humans.

Palace

In perhaps one of his more elite projects, Leonardo designed an

Chambord chateau

amazing palace with multi-leveled porticoes. He designated the light and airy top levels to the upper classes, leaving the roads and paths that extended through the lower levels for inhabitation by the merchant classes. The height of the palace was equivalent to the width of the streets below it, and he added porticoes and windows to improve airflow throughout the structure.

In spite of its aesthetic intricacies Leonardo's design had more pragmatic intentions – it was an attempt to ameliorate the narrow, crowded conditions on Milan's existing streets. Many designers and scientists of the day rightly believed these revolting conditions had contributed to the devastating plague that killed almost a third of Milan's population between 1484 and 1486.

Chateau

During his time spent in France with King François I, it is thought that Leonardo helped to design the king's beautiful chateau Chambord. Construction took place between 1519 and 1547, and Leonardo likely worked on initial plans for features such as a double spiral staircase. It was rumoured that the two paths of the spiral staircase allowed the king's wife to take one route and his mistress to take another, thereby avoiding the risk of any awkward chance encounters on the stairs.

Urban aspirations
City designs in a class of their very own

Urban design was of major interest during the Renaissance as cities grew and became more tightly controlled by ruling factions. Cities needed a place for people to gather for political and social events, and this gave rise to the formation of the town centre. The public space, or *piazza* as it was known in Italy, was one of the most common architectural features designed during the Renaissance. Other popular city building projects during this period were defense towers and palaces, both remarkably common during the 15th and 16th centuries as highly visible symbols of a ruling family's wealth and influence.

Urban design stood out as a new and important field, and Leonardo developed a taste for it. His notebooks are filled with sketches of not only buildings, but also bridges, tunnels, streets and entire cityscapes.

As Milan's population grew, Leonardo sketched out a proposal for separated satellite cities that would surround a central core. Sounds a bit like a modern-day suburbia, doesn't it? Controversially he also proposed the idea for a multi-level city. In this vision the population would be divided according to social status, with the workers and craftsmen functioning on the lower levels beneath the wealthy, the clergy, and others citizens of more noble stature.

Applying his classical principles to urban design, Leonardo devised a system of architectural proportion whereby city streets had to be at least as wide as the houses were tall.

While Leonardo's goals of cleaning up Milan were certainly admirable, it's evident today that his schemes were inadequately engineered. Nevertheless, his sketches of separate transportation passageways for horse-drawn wagons and foot travellers pre-figured identical developments in modern city planning.

CARTOGRAPHIC PIONEER

Leonardo was a pioneer in the field of cartography, particularly in the production of accurate city maps. His map for the town of Imola, produced during his time in Florence around 1502, is thought to be one of the first geometrically precise town plans. This plan may have had strategic importance, as notes included along with the drawing contain distances and directions to various locations.

Observe, understand
The first modern scientist

Leonardo devoted a great deal of time to the study of science and for the period in which he lived, his methods of scientific inquiry were utterly unique. His methodology was simply to first observe the natural world and then attempt to understand and explain his observations. For this Leonardo has been heralded by some as the first modern scientist, since his revolutionary methods became a blueprint for those we use today.

Although Leonardo's observation-based methods may seem a completely logical approach to us today, bear in mind that his technique was completely radical in an age where most people simply accepted the teachings of the Bible to explain the world around them. He would ask a seemingly simple question such as 'How do birds fly?' and then spend weeks or months making painstaking observations to answer this question. These observations would include watching birds in flight, sketching birds in various poses, observing living birds close-up, and dissecting dead

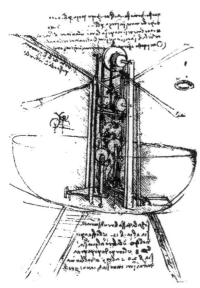

Drawing of a flying machine

birds to understand their musculature and anatomy. With an understanding of bird flight gained from these detailed observations, he would then translate his notes into a more general theoretical understanding of aerodynamics and flight. And being a hands-on type who would never back away from a challenge, this theory would then be applied to designing flying machines to give humans the same experience as birds.

Leonardo's tenacity and varied interests allowed him to make important observations and discoveries across a wide range of scientific disciplines. His investigations lead him to study anatomy and zoology, and to perform detailed dissections on both animals and humans. He also held a keen fascination for botany and geology, and the properties of water.

While one of the hallmarks of the Renaissance was the rediscovery of writings from ancient Greece and Rome, Leonardo actually based very little of his scientific work on these classical treasures. Perhaps because of Leonardo's preference for doing things his own way, or perhaps because he lacked a strong grasp of the Latin language, he wasn't constrained by classical methods and insights. Instead Leonardo developed his own very unique theories and methods of scientific inquiry.

PICTURES WORTH A THOUSAND WORDS
As well as his methods of scientific inquiry, Leonardo also was a pioneer of scientific illustration. This in turn

led to the modern-day concept of illustrated textbooks. He filled many of his notebooks with meticulous sketches of various anatomical and mechanical principles, accompanied by detailed notes. Unlike his predecessors who relied on long written explanations, Leonardo believed that his sketches and drawings were the primary tool in illustrating his various points; his written notes were merely secondary.

A pound of flesh
Anatomical exploration

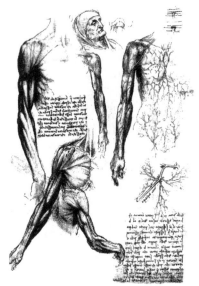

Drawings of a dead or Moribund man

During his lifetime the field of medicine was becoming more prominent, and artists such as Leonardo became increasingly fascinated in rendering the human body accurately in their quest for greater artistic realism. Leonardo's early paintings were studies in the new, realistic style of art, and he was far ahead of his contemporaries in the quality of his representations. The best example of his achievements is perhaps his *Vitruvian Man* drawing of 1490 that broke down barriers as one

of the first accurate expressions of the relationship between the human form and geometrical proportions.

Leonardo never stopped trying to learn about the human body – he might even be called art's first forensic scientist. Not content just to draw the body as he saw it from the outside, he strove to understand the human form from the inside. How far would he go to increase this understanding? In actual fact, much farther than was

acceptable or even legal at that time. In his extraordinary quest for greater realism he cut up cadavers and studied organs as well as skeletal substructures, all in an effort to draw and paint more accurately. Circulation and musculature systems intrigued him for the same reason. What mattered above all else to Leonardo was the quality of his art, and he was willing to get his hands dirty, literally, to guarantee this.

In 1489 he started working on a notebook that would focus specifically on anatomy. He studied all parts of the body, especially the brain and eyes. He sketched skulls in cross-section, showing both an amazing understanding of the visible and an interpretive ability to decipher the unknown. He realized that people see things in different ways depending on their relative positions, and his visual study of the human eye was likely a natural extension of his work in perspective. One of Leonardo's sketches from 1489 compares the human head to an onion, perhaps alluding to its layers of complexity.

Leonardo also paid particular attention to musculature, as can be seen in several of his sketches.

Some of his earlier anatomical drawings show extremely muscular men (perhaps indicating his own preferences), while later sketches focus on more anatomical detail. A series of shoulder drawings from 1511 show tremendous schematic detail on the layering of bodies depicting skin, bone, muscle and surrounding tissue as a complex web. Leonardo's paintings from 20 years earlier show this same fascination with the muscle groups that added sculpted definition to his art.

ACKNOWLEDGING THE DIVINE

Leonardo's work in detailing the nature of organs that had been previously undefined was extremely daring for the time. Renaissance clergy were of the mind that the heart was a spiritual element, not just a muscle like any other in the body. Although Leonardo explored science in rational, realistic terms, he did not dismiss spiritual notions. He consistently acknowledged the divine in his scientific studies, marveling at the complex beauty God had created.

Life through death
Pioneer in corpse dissection

Leonardo was a pioneer in the rather gruesome yet fascinating occupation of corpse dissection. He realized that the best way to learn about the inner workings of the human body for his artistic and scientific studies was, quite simply, to take a look inside. In order to study musculature and bone structures in the arms, legs and other body parts Leonardo dissected many corpses during the early 1500s.

His subjects appear to have included a homeless woman who had been about nine months pregnant at the time of her death. One of his sketches depicts a curled human fetus

*Studies of embryos
(Pen over red chalk
1510–1513)*

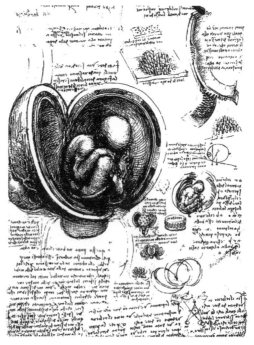

and umbilical cord as they lie inside the womb. However the unborn baby is a highly muscular infant – from this error, we can see that his factual knowledge was probably minimal. Despite some mistakes, Leonardo was one of the first to draw the female reproductive system relatively accurately, and his drawings are without a doubt the most detailed to come from the Renaissance period. He also drew intricate sketches of other human systems and organs, including the heart. He even made three-dimensional models of human body parts based on his studies of cadavers.

Moreover it wasn't just the body structure that fascinated Leonardo; he plunged deeper inside to study blood circulation and the heart, first in the 1490s and again about 20 years later when he produced a series of drawings on the subject. He used his studies to map out the basics – the heart being a four-chambered muscle that was somehow connected to the pulse felt in a wrist. He also established that arteries could become overfilled and that this situation could lead to sickness or even death,

thereby predicting the concept of clogged arteries, an ailment that would become a major medical focus in later centuries. Yet Leonardo never managed to conclude the precise connection between blood flow and the heart muscle.

SEX AND THE SPIRITUAL
Leonardo was particularly fascinated in human reproduction. The popular view during the Renaissance was that bodily organs were divine, spiritual entities, an idea that had been considered a truism for centuries. In keeping with this tradition Leonardo started out believing that the main outputs of the male sex organs were essentially sperm and spirit, and that the human reproductive organs were connected by a direct channel to the heart, the lungs and the brain. Through his research he quickly realized that this approach was wrong because it could not be proven. His anatomical explorations showed the true connections between body parts, and revealed no such evidence of a spiritual channel.

Flora and fauna
Studying plants and animals

Leonardo began a long tradition of drawing and painting animals by studying them in the wild. From his earliest days, long before his apprenticeship to Andrea Verrocchio, Leonardo spent hours studying animals and how they moved.

As a result animals of all kinds feature in many of his paintings, some moving and some standing still. Leonardo also rendered flora in extraordinary detail, capturing plants with the same keen aspect of realism so apparent in his animal studies.

Fauna

The horse was one of Leonardo's favourite animals, and the one he sketched the most. He drew horses standing, sleeping and in various states of motion. He also modeled them in three dimensions, including the infamous *Statue of Francesco Sforza* as well as many smaller bronze models that he bequeathed to his final patron King François I of France.

Leonardo's notebooks also prominently feature cats. He wrote stories about them and sketched them in precise detail. He drew feline subjects in a variety of poses, both asleep and in motion, and Leonardo gave a cat centre stage in at least one work, *Madonna with the Cat*. Leonardo painted other animals throughout his career including pigs, bears, goats and birds. He also rendered drawings of animals that looked like either crossbreeds or completely fictional beasts, including some utterly fantastical dragons.

Leonardo wished to render animals as accurately as possible and quickly realized he would have to learn more

Star of Bethlehem *sketch*

about how their bodies functioned. His notebooks tell us that he made several visits to slaughterhouses and his sketches contain studies of dissected animals, including some highly detailed drawings of pig hearts. It seems that he spent time observing the actual slaughter of pigs – once their innards were revealed, Leonardo was able to view the still-beating heart and observe how blood was moving from the heart through the arteries.

Flora

Leonardo's interest in the natural world spread to the abundance of flora as well as fauna. Unfortunately Leonardo's plant sketches are some of the worst preserved of any of his drawings. One sketch that does still exist is the *Star of Bethlehem,* which was created between 1505 and 1507 and is significant because, in addition to being one of his few surviving plant drawings, it depicts a highly stylized, abstract flower.

In contrast, most of his earlier plant drawings were more scientifically accurate and Leonardo is renowned for the remarkably detailed botanical

renderings of various plants and trees in a selection of his work. While many Renaissance artists focused exclusively on the painting's central figure Leonardo paid attention to every detail, and his work is significantly richer because of it.

Poster child
Icon of the Renaissance

Undoubtedly one of the most famous drawings of all time is Leonardo's *Vitruvian Man* of 1490. His image has become an icon for art, science and the Renaissance. Today, it is such a widely recognized symbol that it can be seen everywhere – in textbooks, museum galleries, medical institutions, and even on T-shirts. So what is the fascination about this particular drawing?

The architect

It should come as no surprise that the source of inspiration for the work was a fellow named Vitruvius. The Roman chief architect Marcus Vitruvius Pollio served under Julius Caesar in the 1st century BC. He codified the first basic principles of architecture and

Vetruvian Man

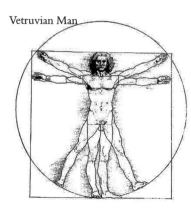

was an expert in urban planning and structural design.

He also wrote the first definitive treatise on architecture entitled *The Ten Books of Architecture* around the year of 27 BC. In this he asserted that a structure must exhibit the three qualities of *firmitas, utilitas, venustas* – that is, it must be solid, useful, beautiful. He went on to explain the importance of nature in establishing form and proportion, culminating in what he considered the greatest source of inspiration, namely the human body. Along these lines he specified guidelines for city planning, building materials, hydraulics and other major civic projects. He also established distinguishing criteria for religious,

private and public designs, the first time these had been defined so clearly.

The man

The original sketch of the *Vetruvian Man* now resides in Venice and measures approximately 25 x 33cm (10 x 13in). It comprises a square partially inscribed within a circle, with a human male form inscribed within these two basic geometric shapes. The pivotal reason for this drawing's notoriety is because it is the very first representation true to the proportions of an idealized human form, as originally defined by Vetruvius.

In addition this sketch, and the notes that go with it, show how Leonardo understood the proportions of the human body in that each separate part was a simple fraction of the whole. For example the head, measured from the forehead to the chin, was exactly one-tenth of the total height, and the outstretched arms were always as wide as the body was tall.

Architecture, for Leonardo and other Renaissance architects, was a matter of harmonious modularity. As Leonardo proved with this drawing, it was possible

to view the human body in the same way – as a symmetrical composition of anatomical building blocks. The principle defined in this drawing was the catalyst that completely revolutionized figure drawing.

At a higher level still, Leonardo had successfully combined art and Humanist ideals into a representation of both science and nature. Over time this came to symbolize symmetry within the universe as a whole and the drawing has become a poster child for Renaissance ideals.

Solid as a rock
Leonardo the geologist

While the majesty of Leonardo's artistic talents was most certainly realized during his lifetime, Leonardo's scientific discoveries were largely underappreciated. This lack of appreciation can most probably be attributed to society at the time simply lacking the context in which to appreciate the extent of his genius. Leonardo, however, seemed to thoroughly enjoy his scientific work. While his biographer Giorgio Vasari rued the fact that Leonardo spent too much time dallying with his scientific pursuits, Leonardo himself sometimes felt that his works of art distracted him from his science.

In geology Leonardo's theoretical contribution is particularly striking. Whilst working at Ludovico Sforza's court, Leonardo most likely had ample time to study the area's various rocks. From his writings we know that Leonardo understood the key geological cycle of sedimentary rock formation and erosion. He also established that, as a result of erosion, sand and rock particles are eventually carried to the ocean, thus to repeat the cycle.

Furthermore, Leonardo discovered that sedimentary rocks are organized in a way that allows the observer to determine relative ages. Since they are deposited in an orderly pattern over long periods, Leonardo realized that the oldest rocks will form the base of any undisturbed series of layers, and that younger rocks are layered on top forming distinctly visible layers where they are exposed. It is astounding to learn that scientist Nicolaus Steno did not rediscover these principles for almost 300 years after Leonardo's death.

The nature of fossils
Rejecting existing theories

Leonardo was fascinated with fossils, and was particularly puzzled by the discovery of what were clearly the fossilized remains of sea creatures at extremely high altitudes. A popular area of geological research during Leonardo's day, he rejected the two main theories prevalent at that time for this. One suggested that the great flood described in the Bible had carried the remains to these higher altitudes. The other theory suggested that these sea creatures present as fossils at high elevation had actually in some way lived and then formed right inside the rocks.

Leonardo applied his unique methods of scientific inquiry to consider and subsequently rule out both of these theories. From his observations of nature, Leonardo knew that these fossils were the shell-like remains of living creatures with a need to move so they could eat and grow – this meant they couldn't have formed inside a rock. He also concluded that a single great flood most likely never covered the world, simply since the water would have had nowhere to drain.

Leonardo's explanation

After dismissing both predominant theories, Leonardo tackled the problem himself and devised an alternative explanation. Remarkably, Leonardo's solution to this puzzle came amazingly close to the modern understanding. He suggested that when the fossils had been living sea creatures, they had naturally occupied an ocean environment. As mountains later formed where these oceans had once lain, ocean sediments incorporating the remains of these sea creatures were gradually elevated to the mountain peaks.

Today we know that this model is an astounding approximation of what did in fact happen. The crust of the earth is mobile due to plate tectonics, and mountains can form when one plate slides under another, but also when two plates push up against each other. If an ocean had previously deposited material on these rising plates, the fossilized remains were elevated with them and would finally

arrive on the mountain tops millions of years later. Leonardo had very nearly solved the mystery of the land-locked sea creatures.

Reaching for the stars
Reflections on astronomy

I t was perhaps inevitable that Leonardo would turn his passion for observing nature upwards eventually to the heavens to observe and plot the positions of the stars and planets in the sky. And it was from these observations that he was able to make a number of amazingly accurate astronomical discoveries.

For instance, whilst many of Leonardo's contemporaries believed that the stars were just tiny dots of light in the sky, Leonardo realized that they were essentially of the same nature as our sun, their small size simply the result of their greater distance from Earth. From some writings it seems that Leonardo also appears to have believed that the moon orbited around the earth, and that the earth itself was shaped like a sphere rather than a flat disc. Both these theories would have been staggering leaps forward for his day.

Leonardo mentioned that to an observer on another planet, the earth

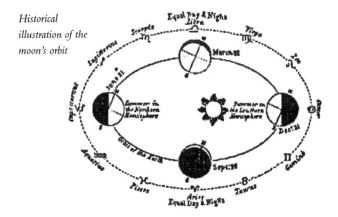

Historical illustration of the moon's orbit

itself would resemble a star in the sky just as the other planets in our solar system appear like stars in our night sky without a telescope. He produced sketches of the geometry of lunar and solar eclipses, and invented a lunar clock to display the phases of the moon, basing its design on his detailed understanding of the earth's rotation. Leonardo also realized that due to the rotation of the earth, sunrise occurred at different times in different locations. This observation came long before time zones were established.

Less correctly, Leonardo believed the moon reflected the light of the sun because it was covered with water; of course, we now know that the moon is a completely dry world. He also predicted that the moon had an atmosphere, and thought that the moon's larger size when viewed on Earth's horizon than when viewed high in the sky was because of distortions in the lunar atmosphere. Today, we understand that this apparent enlargement is simply an optical illusion.

Divine proportion
An obsession with geometry

L eonardo was intrigued in theoretical scientific disciplines such as mathematics, in particular geometry. In 1496 the well-known mathematician Luca Pacioli (1445–1517) was invited to Ludovico Sforza's court, nominally to teach mathematics there – it is believed that Leonardo may well have recommended this invitation to the Duke. Leonardo and Pacioli became the greatest of friends, apparently spending much time together mooting the overlap between art and mathematics.

During this time Pacioli was writing his *Divina Proportione*, a book published in 1509 as the first of a three-volume set. The book focused on the so-called Golden Ratio, which Pacioli called the Divine Proportion. This Golden Ratio has an algebraic value equal to about 1.6180 and is considered to represent a particularly elegant relationship in both art and mathematics. The ratio was equally important in architecture, and the second volume of Pacioli's *Divina*

Proportione focused on the ratio's architectural applications.

Pacioli's book also included a study of polygons, or shapes with multiple sides. Leonardo was naturally fascinated by the entire project, and drew illustrations to accompany the text. As he worked alongside Pacioli he became particularly obsessed with geometry, and it appears he actually set his painting to one side to accommodate this obsession. A court letter dated 1501 to Isabella d'Este, who had commissioned a portrait from Leonardo, stated that the master's mathematical explorations were taking up most of his time, and he could not spare time to paint.

Leonardo's drawings of three-dimensional polyhedra were the highlight of Pacioli's book. Leonardo devised a new way of drawing these complex shapes showing them with solid edges and hollow faces that allowed the viewer to see right through them. This method of drawing shapes was an important breakthrough for the day, and it took a visual artist of Leonardo's talents to conceptualize.

In addition to his work for Pacioli,

Leonardo's three-dimensional polyhedra

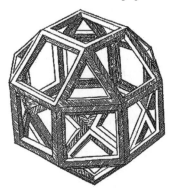

Leonardo spent time alone in Milan conducting his own research into geometry based on the teachings of Pacioli and the Greek mathematician Euclid (c 300 BC). He was predominantly interested in trying to 'square a circle', meaning he sought to create a square with the same area as a specific circle, using only drawing tools such as a ruler and compass.

LEONARDO'S CALCULATOR
Beyond his theoretical work in mathematics, Leonardo put thought into mechanical methods of automating mathematical work and designed a machine that was one

of the first calculators. A working replica was built in 1968, but whether or not this replica actually represented Leonardo's intention is another story. The sketches on which the calculating machine replica was based are unclear, and it's possible that the machine was not, in fact, a calculating machine but a ratio machine instead.

Hell and high water
A fascination for water

Leonardo was utterly fascinated with water. He went to great depths to study its properties, and his observations were right on target. In his notes he wrote that water could smoothly transform in character depending on the environment in which it found itself. It could be fresh or salty, it could flow furiously or calmly, and it could nourish as well as destroy. He understood the power water had to revitalize plants, animals and people, and he was also acutely aware of its ferociousness, this being clearly demonstrated in his studies of powerful storms and

the extraordinary sketches of water in turmoil that accompanied these copious studies.

Leonardo studied the various ways in which water moved around the planet, noting that it could fall as rain, melt as snow, run in rivers, and even well up from the earth itself. He studied currents and waves, observing how surfaces that repeatedly came into contact with moving water degraded over time. He may have actually been the first to suggest the concept of erosion. However, he wasn't foolish enough to think that water was harmless – he realized its violence, and probably feared the destruction that could be caused by swollen rivers.

Against the flow
One of Leonardo's most dramatic ideas to control water was an ambitious scheme to divert the path of the great Arno River near Florence. In 1502 Leonardo was in Imola working as chief engineer for Cesare Borgia. He used his skills in cartography to plot out the course of the river, and in 1503 he presented a plan to redirect the river between

Imola, Florence and the sea. As a part of the river diversion project, Leonardo also decided to revamp the Florentine canal system to construct a series of channels that would also lead to the sea. This effort would have improved the city's waterpower, irrigation and commercial status, ultimately transforming the city into a bustling seaport.

Unlike many of Leonardo's projects, this one was at least started. Hundreds of men began working on the canals under the supervision a master hydraulic engineer. Unfortunately these canals were never completed correctly, as Leonardo had to return to Florence from Imola in order to continue work on a fresco in the Palazzo Vecchio. In Leonardo's absence, the master engineer took liberties with the design and made some disastrous engineering alterations to the plan. Under this poor direction, the ditches were dug too narrow and in the wrong position; he also didn't hire sufficient men to come close to completing the project. According to some reports, the Arno actually did flow in its new path for a short time, but the river

promptly reverted to its previous course and the project was eventually abandoned.

Age of innovation
The father of invention

Whether they were aware of it or not, Renaissance inventors were at a crossroads. Europe was slowly emerging from the Dark Ages and there had already been several significant inventions. At the same time, some of history's greatest

Galileo's pendulum clock

achievements were yet to come. The Renaissance world was moving apace on an immense wave of innovation and invention, and Leonardo was riding right on its crest.

Against what backdrop can we view Leonardo's inventions? Undoubtedly Leonardo and his contemporaries didn't have access to most of the modern conveniences we take for granted today. Most noticeably lacking would have been the indoor toilet, which was not mass-produced until the late 19th century. And since electricity wasn't even discovered until the 17th century and not widely used until the late 1800s, of course Leonardo and his contemporaries couldn't turn on the lights.

One of the most significant inventions of the Renaissance was the mechanical timepiece. Clocks were first created in the 1300s, but it was not until the late 1500s that Galileo (1564-1642) developed the idea for a pendulum. Eyeglasses were another significant medieval and Renaissance invention, and as early as the 1300s Venetian guilds were regulating eyeglass production. Eyeglasses would

have been considered a luxury item, but when Johannes Gutenberg's invention of the printing press transformed reading into more of a hobby than a luxury, they came into higher demand. Everyone wanted to read, and their eyes needed to keep up with them.

Perhaps most importantly, the fact that books were now widely available would have been a critical development for a scholar like Leonardo. It meant that the writings of ancient masters were now available to him and from them he could create his own interpretations and innovations. And his work didn't stop with reading alone – if books could be published easily, he could also publish his own writings.

Leonardo was thinking, sketching, and designing with these innovations as his backdrop. These historical developments should not be underestimated as they influenced Leonardo in many ways – providing a context into which his ideas would fit, inspiring future designs, and prompting the Renaissance master to continue pushing the boundaries of understanding to extremes.

Going against the grain
Contributing to the war effort

Renaissance Italy was nothing more or less than a war zone as warring factions constantly competed for dominance of the fragmented landscape. Because war played an integral part of their life, architects, engineers and other designers paid considerable attention to military improvements. As engineers across the land rose to the challenge of creating ever more advanced war machines, Leonardo also found himself contributing significantly to this ongoing war effort.

The technology behind artillery was improving, and suddenly it was necessary for wars to be fought differently. As walled cities developed and housed larger populations, siege warfare was becoming increasingly common, thereby lessening the need for hand-to-hand combat. Leonardo was very much aware of the destructive potential of siege warfare – as a designer living in Renaissance Italy, there's no way he could not have been.

In an effort to help his country, he designed both new weapons and entirely new weapon systems. He also came up with ideas for many kinds of military land vehicles. Some of Leonardo's vehicle ideas

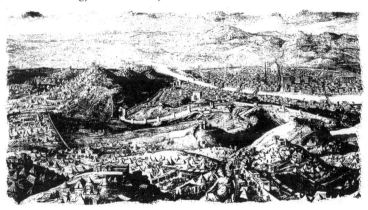

Siege of Florence, 1530

were quite practical, while others appear primarily conceptual and were probably never intended to be actually built.

THE PACIFIST

Although he lived in a society that required a strong military to survive, Leonardo may have been more of a pacifist. His notes describe how he thought that fighting, death and survival of the fittest were qualities for animals, rather than people. However since Leonardo probably wanted to stay employed by his patrons, it seems doubtful that he would have expressed these views in public, reserving them rather for his private notebooks.

Snakes and ladders
On the offense and defense

In warfare, Leonardo became preoccupied with both offense and defense. When several Florentine forts were attacked in 1479, Leonardo became absorbed in designing methods for scaling walls during a fort attack as well as methods for

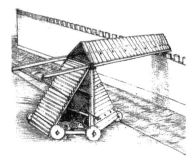

Leonardo's siege ladders

defending against those same efforts.

Subsequently Leonardo designed a number of different ladders for wall climbing. Some were stiff and solid, while others were flexible and made from rope. To attach them securely, some of Leonardo's ladders had hooks that could fix on to the top of the wall, while others had spikes on the base to keep them immobile on the ground. He also created ideas for flexible ladders that could hang from a wall, as well as an early design for the type of chain ladder that's still often used for fire escapes today.

During his time with Ludovico Sforza, Leonardo designed a number of bridges for military applications. Some of these bridges were portable

so troops could carry the bridges with them and set them up quickly when needed. Others were designed to be particularly strong and resistant to fire or other means of destruction. Leonardo also considered and developed methods for soldiers to burn and destroy enemy bridges.

Leonardo's military bridges had a number of different designs. One was arched in such a way as to be particularly strong when assembled. Others used traditional pilings, or were flexible so they could swing without breaking. Leonardo also designed adjustable jacks for opposite sides of a river, to be used if the banks were different heights on each side.

BRIDGING THE GAP

Leonardo designed one particularly impressive military bridge during his time with Cesare Borgia. In order to span the Bosporus at an inlet called the Golden Horn, Leonardo suggested building an enormous bridge across the Gulf of Istanbul. This route would have had immense strategic importance, but other engineers vetoed the plan when they saw just how enormous the bridge would have to be. Modern studies of Leonardo's design for the bridge show that the structure would have definitely been possible to build with the resources of that era, and that the bridge itself would have been solid and well designed. In fact, a smaller version of Leonardo's bridge was built in Norway in 2001, a mere 500 years after Leonardo's original design.

War games
Military movements

Vehicles that could serve offensive or defensive purposes piqued Leonardo's design curiosity. It is incredible to learn that this essentially peace-loving artist created an amazingly gruesome design for a horse-drawn chariot with four large scythe-like blades mounted to the axles. As the horse pulled the chariot the blades would rotate, slicing off the limbs of enemy soldiers or anyone unlucky enough to get in the vehicle's way.

A variation on the design placed the four large blades in front of the machine and the horses, where a

screw-type device turned them. This model also included a series of smaller scythe blades at the back of the chariot. Designed as a brutal weapon, even Leonardo's initial sketches showed images of dead and dying soldiers left in its wake.

LEONARDO'S TANK

One of Leonardo's largest military vehicle designs was for an armoured tank. The idea was simple and deadly – protect passengers while causing as much damage as possible. In his tank design Leonardo didn't specify the powering mechanism, but his notes indicate that his tank could have been either hand-cranked or drawn by horses. If hand-powered, the cranks would have been connected to gears which, in turn, connected to the main driving wheels. The entire vehicle would be under a hard shell; in physical appearance Leonardo's bizarre drawing resembles something somewhere between a turtle and a spaceship. The structure would have been clad in metal panels and, as in today's tanks, it would

have had holes from which the guns protruded. Of the two possible power sources, the hand-cranked version probably would have worked better than the horse-drawn one; as well as being vulnerable horses might not have remained calm enough during battle to power the tank. In this design, as in many others, Leonardo was far ahead of his time. The armoured tank that is used in modern battles is, of course, a motorized vehicle that runs on high-tread tracks. Yet it didn't come along for nearly another 400 years; the first armoured tank to be a direct precursor to the modern tank was created in England around 1916.

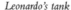
Leonardo's tank

No ordinary weapon
Larger-than-life weapons of mass destruction

L eonardo designed or improved a number of weapons. Guns, cannons and other artillery weapons became increasingly popular during the Renaissance and newer was deemed better, particularly when it came to national defense.

However it's interesting to learn Leonardo did appear to have had a nostalgic side when it came to weaponry, spending time as he did working to perfect or improve traditional models such as catapults, slingshots and crossbows. Also fascinating is the result of Leonardo's innovations, bringing about change not only in the nature of weapons, but also in the way in which they were used.

Crossbow

The early crossbow was easy to construct and could be shot by just about anyone, so it rapidly became a highly desirable weapon. Naturally Leonardo's design was for no ordinary crossbow – his comprised

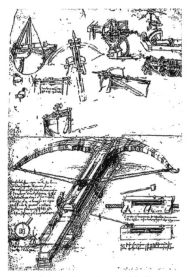

Leonardo's giant crossbow and ballista

four crossbows powered by a large treadmill. A number of men walked on steps that were located around the outside of a large wheel, and as they made the machine rotate an archer would fire each crossbow, reloading them in sequence. What was unique about Leonardo's design is that it changed the fundamental nature of the crossbow from being a weapon that an individual functioned alone to one requiring a collaborative team effort. In this, historians believe it

represented as much a redesign of the whole of society as a redesign of the weapon itself.

Leonardo also designed a mammoth crossbow that required six wheels to manoeuvre it. This device, also known as a ballista, used a series of gears to draw back the bow; a simple strike of a pin would release the shaft. Similarly he also designed a giant slingshot, and in the interest of defeating more enemies in less time, he devised a rapid-loading catapult system. Were Leonardo's giant weapons actually usable, or were they just an example of 'bigger is better' taken to an extreme? We'll never know, because they were never built.

Cannon

While cannon were first used as early as 1346, they hadn't advanced by Leonardo's time. One of Leonardo's first improvements to cannon design was to create a model that could be loaded from the rear, rather than down the front of the barrel. And since the cannons had to be cooled before they could be reloaded, Leonardo suggested putting them in a vat of water to hasten the process.

Not a bad idea, but would *you* want to be the one to lift a hot cannon into a tub?

Another invention of Leonardo's was a steam-powered cannon. The end of the cannon was heated to a high temperature, and then a small amount of water was placed inside the hot cannon. As the water turned to steam, the increased pressure shot out the cannonball. Leonardo's notebooks include information on the size of cannonballs that the device could use, and the distance they could travel. These details suggest that, unlike most of his inventions, this one may actually have been built and tested as well.

Blue-sky thinking
A life-long passion for flight

Leonardo had a life-long passion for flight. Whether human-powered or machine-aided, taking to the air was a goal that seemed to have engrossed him since childhood. His notebooks are filled with sketches for various types of flying machines and some have been built in modern times, with varying degrees of success.

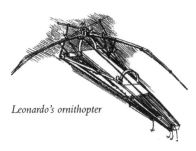

Leonardo's ornithopter

One idea he studied repeatedly in the late 1480s was that of an ornithopter, an aircraft designed to fly by means of flapping wings. He seems to have been the first person in recorded history with this idea, and it was one that continued to obsess him for years. Leonardo's initial ornithopter designs required balance and strength to flap the crafts' wings, however he quickly realized that the undue level of coordination required would be too much to expect from most people. For that reason he also focused on a series of simpler designs.

One of these was for a glider system with birdlike wings; the pilot would climb in, jump off a high starting point, and balance largely by moving the lower body in synchronization with the wings. He created another version of this design where the pilot would move his legs up and down, and yet another in which a spring-loaded mechanism did most of the work.

Leonardo spent a great deal of time developing his flapping mechanisms. Unfortunately, he paid very little attention to the role feathers play in flight – this turned out to be one of his greatest oversights. Moreover, as his flying machines became more complex, they also got heavier and therefore less likely to actually succeed. Toward the end of his life, Leonardo focused primarily on fixed-wing craft that relied more heavily on the concept of lift than on the physical act of flapping. These, at least, had some hope of getting off the ground some day.

TEST FLIGHTS

It's interesting to learn that the Codex Atlanticus, *one of Leonardo's many notebooks, contains copious notes on flying machines. It also mentions test flights that may actually have been conducted from* Mount Ceceri in Italy; *supposedly a student broke a leg while conducting such a flight. Unlike most of his*

inventions Leonardo, or at least his unwitting students, tested at least a few of his designs for flying machines. How successful they were, though, is open for debate.

Leonardo's helicopter

The whirlybird
Early helicopter designs

Leonardo had an obsession with flight that was insatiable. In addition to parachutes, gliders, bat wings and other assorted flying machines, Leonardo created one of the world's earliest helicopter designs.

Leonardo's helicopter used a corkscrew-shaped propeller instead of the blades on modern helicopters, and the occupants rode on a platform below the dominant screw-shaped blade. Leonardo's idea was to use a spring-loaded system that would wind up the helicopter blade and then release it. If this screw spun fast enough he hypothesized, the entire machine would lift from the ground.

What is unclear from Leonardo's helicopter design is whether or not the occupants would have been spinning along with the blade. The

very idea is quite nauseating, so it's perhaps a blessing that the design was never tested during his lifetime. As with his other flying machines, the major problem with the design would have been the craft's weight – it simply would have been too heavy to lift off the ground.

LATER COPTERS
Helicopter design didn't solidify until the early 20th century. The first helicopter to actually take to the air was invented by a French designer named Etienne Oehmichen in 1924, but this only flew about half a mile. After many years of failed designs Leonardo's dream came to fruition when Igor Sikorsky studied the Renaissance genius' designs in detail. Using Leonardo's design as a starting point, in 1910 this

Russian aviator and designer began drawing prototypes for the first fully functioning helicopter. One of the most fascinating aspects of Leonardo's original design was that he conceived the helicopter as a single, unified, elegant whole. Although it included a minor substructure, the screw-like propeller was almost the entire machine. While modern equipment is a cacophony of moving parts, Leonardo's original design was elegant and simple.

On a wing and a prayer
Parachute proved flightworthy

L eonardo explored all avenues when it came to flight, and his first parachute design, seen in one of his early notebooks, probably dates from 1485. It looks very much like a modern kite, with a person dangling from a pyramid-shaped fabric structure that was held together by rigid poles. The parachute itself would probably have been made of linen, sealed at the edges so it wouldn't unravel or fray during flight.

Leonardo's most common designs

looked rather like inverted ice cream cones; more advanced sketches showed a human sailing through the air suspended from large fabric wings. The adventurer could manoeuvre his or her way through the sky by leaning to one side or the other, the result resembling modern-day hang gliders. Like most of his other inventions, however, Leonardo's parachute was never built and tested during his lifetime. One of the biggest hurdles was probably finding something high enough to jump from, or maybe even someone prepared to make the jump.

Testing his design
The first known attempt to build Leonardo's parachute came in 1617 at the hands of Italian designer Fauste Veranzio (1551–1617). He supposedly built a parachute based on Leonardo's drawings of 120 years earlier, testing it by jumping from a tower in Venice. Leonardo's design was more fully tested in June 2000 by a British skydiver and camera flyer called Adrian Nicholas (1962–2005). After constructing a version of Leonardo's design using canvas, wooden poles and ropes, Nicholas jumped from a

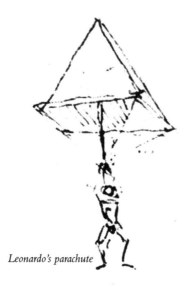

Leonardo's parachute

hot air balloon at a height of 3,000m (10,000ft) and, incredibly, landed completely safely.

Amazingly Leonardo's parachute actually floated to the ground more slowly than a modern-day parachute would have. While most people thought that Leonardo's design wouldn't work or would spin too much to keep the occupant from excessive nausea, Nicholas proved that the master's design was indeed flightworthy. Today a model of

Leonardo's parachute hangs in the British Library in London.

MODERN SIGNIFICANCE
The parachute, as first designed by Leonardo, has had enormous impact on our world today. Parachutes slowed the Apollo and Mercury space capsules down on re-entry to the Earth's atmosphere so they could drop safely into the ocean, and also landed the recent robotic space missions on Mars. They are used when landing fighter jets on short runways, such as those on aircraft carriers, and as routine life-saving devices on airplanes. Leonardo's design, while not directly linked to these later iterations, provided the initial inspiration that such a revolutionary concept of this kind could actually work.

Leonardo's monster
His amazing mechanical robot

Leonardo was one of the first to study robotics, but not the first. The very first known foray into what would become modern-day

robotics was when the ancient Greek mathematician Archytas of Tarentum (428–347 BC) developed a steam-powered bird. About a hundred years after Archytas, another Greek named Ctesibus (285–222 BC) developed a mechanical water-clock design.

In 1495 Leonardo sketched out an idea for a mechanical, humanlike robot – this may well have been the first design of a robotic human form in history. In the drawing the robot looks like a knight since it appears to be wearing a suit of armour. Its purpose being somewhat unclear, it is believed Leonardo may even have designed it for fun. In any case, Leonardo's robot could turn its head via a bendable neck, open and close its jaw, move its arms, and sit up and down. It incorporated at least two gear systems that operated independently of each other; one to control the lower body (legs, feet, hips) and one for the upper body (arms, shoulders, hands).

Historians are not certain whether a physical model of Leonardo's robot was ever constructed. The design was misplaced for many years and was only rediscovered in the 1950s.

Computer models of Leonardo's design have since been constructed, attempting to show how his robot might have been realized in 16th-century Italy.

One of the first precursors to the modern mechanical robot was created 200 years after Leonardo when French engineer Jacques Vaucanson (1709–1782) built a mechanical duck (of all things) with hundreds of moving parts. The 19th century saw the introduction of the idea of fantastical humanlike machines as featured in Mary Shelley's seminal novel *Frankenstein*. Finally, in the 20th century robot development took off apace, and robots are now used for everything from children's toys to manufacturing to space exploration.

Walking under water
Futuristic diving apparatus

Leonardo constantly pursued improvements in the way man functioned in water. Preliminary research into deep-sea exploration began in the Renaissance, and Leonardo's ideas were influenced by this new interest in exploring

the ocean's depths. He worked on expanding the length of time a diver could stay under water, and he also sought ways to protect the submerged diver. Many of Leonardo's aquatic inventions for divers were never tested, but some are amazingly similar to devices used today.

Leonardo's apparatus for walking on water

Diving suit

Leonardo's sketches of divers show them in suits that could be used on land and sea at the same time – essentially frogmen – and included land necessities such as regular clothes, ropes and weapons. The diving suit itself was to be made of leather or another durable animal skin with cane hoses to allow the diver to move and breathe easily. Leonardo also reinforced the suit with metal so that the pressure of the deep wouldn't threaten the safety of the suit's incumbent.

It seems that Leonardo did in fact intend this suit for relatively shallow diving only, because the pipe providing air to the diver went directly to the surface. The top of the tube also featured a bell-shaped float, so that the air openings would always remain above water. It is fascinating to learn that modern divers have actually built a suit from Leonardo's notes, and they reported that it functioned pretty well.

Air sack

Leonardo also sketched out an idea for an air sack that may well have sparked later inventors to create oxygen tanks. One such diagram shows the diver with a large, impact-resistant air sack attached to his chest so that he could dive far beneath the surface – however this chamber was likely so bulky that swimming with it might have been

impossible. Leonardo's idea of a wineskin containing air for divers was further explored in the 19th century – Jacques Cousteau and Emile Gagnon eventually saved the day in the 1940s with their development of the necessary valve.

WALKING ON WATER

With true biblical spirit, Leonardo developed ideas in 1480 to allow humans to walk on water. Unlike certain well-known religious icons, Leonardo's water walkers would use special floating devices to keep them from sinking. This addition probably kept Leonardo from being accused a heretic, but also added a touch of essential practicality. These floats would have been attached to the feet of the user, who would have balanced upright by holding on to long poles. Why invent a method by which to walk on water? From his notes it appears that Leonardo simply wanted man to master the art of free movement, despite the apparent obstacle of an unstable surface. Leonardo believed that a human should be free and unrestrained, whether on foot, on water or in the air. His float design was, in a sense, a means to achieve something Leonardo believed should come naturally.

Control freak
Harnessing the power of water

Leonardo had an obsessive fascination for water; he described it as the *vetturale di nature* (vessel of nature). He was intrigued by a desire to harness the inherent power of this force of nature, and between 1485 and 1490 Leonardo developed several schemes to do just that. One of these was for a water pump that could drain an entire port; he also developed pumps that could remove water from a vessel through a valve.

Leonardo's collection of notes *Codex Atlanticus* contains copious designs for water-controlling devices. These include several ideas for sluice gates, or movable panels, that could drop to divert the flow of a river or canal. There are also detailed three-dimensional sketches for dredges that used mooring ropes to wind up the dredge and move it along the shoreline to the next dredging point.

Leonardo also worked on a design to improve the Archimedean screw, an ancient device that used a turning handle to pump water from a well or uphill. It is believed to have been invented by Archimedes (287–212 BC), a Greek mathematician many consider as the father of modern mathematics. Leonardo designed a very large version of the screw that terminated in a handle; when inserted into a well or lake, water would be pumped up at a moderate angle. Variations of Leonardo's design are still in use in some countries today.

Waterwheels in general were of great interest to Leonardo. They had the capacity to quickly replenish military supplies that could be exhausted during a campaign and therefore had a utilitarian purpose – Leonardo always championed inventions that had immediate practical applications. He used a waterwheel as the power source in his designs for a mill that spanned a canal. In this position the paddles on the waterwheel had access to a naturally occurring power source in the flow of the canal, and would operate for as long as water was held at a sufficient height.

Order from chaos
An extraordinary record

From the age of about 37 years old, Leonardo started recording his observations on the world around him in note form – this was a habit he was to continue for the rest of his life. He composed this extraordinary record of his work on loose pieces of paper of varying sizes, jotting down his latest inspirations on whatever scraps he found lying around. These notes authentically reflect Leonardo's own unbridled spirit; instead of being an orderly progression of thoughts, they appear more as a stream of consciousness, nothing less than an unedited outpouring of Leonardo's sheer brilliance.

Leonardo's notes were jumbled and disorderly, but he most likely never intended anyone else to read most of his private records. In any case they were practically illegible; Leonardo wrote in Italian but backwards from right to left, and in a mirror fashion, where all the letters were backwards too. In addition, he invented his own shorthand, abbreviating and combining words, or in some cases

dividing one word into two. To confound matters even further, Leonardo chose to abstain from punctuation.

As a result of the jumbled nature of Leonardo's notes, individual pages may cover a diversity of topics. For example, a page that begins with an astronomical study of the motion of the Earth may end with a discussion of the mixing of colours. Similarly, a page on the structure of the human intestines might finish as a discussion of the relationships between art and poetry. Even pages that cover only one main topic are covered often with sketches or doodles of unrelated subjects.

Fortunately, Leonardo did tend to keep his observations on a subject within a single page and he was careful to indicate if they continued to the back of the page or to a different page altogether. Aside from this care in continuation however, there is almost no overall order or numbering to the pages – in fact few are even dated or numbered at all. Because of their general disorganization, it seems fair to assume that Leonardo never intended to publish his notes in their raw form.

First edition
The tale of a treatise

L eonardo's first published work was entitled *A Treatise on Painting* and appeared in 1651 as a French book. It became incredibly popular and was swiftly reprinted in six different languages. Unfortunately, however, the book wasn't actually based on Leonardo's original notes, but on copies that only contained only small sections of the original. The published edition didn't even use Leonardo's original order or try to combine ideas logically; instead, it

Treatise on Painting

was presented in the random order imposed by whoever made the copy. It now seems amazing that this work was published at all, let alone reached such heights of popularity.

The next significant development in the story of Leonardo's published works occurred in 1880. A da Vinci specialist named Jean Paul Richter, on inspecting a Leonardo manuscript from a private collection, discovered a large fragment of the text from *A Treatise on Painting* in its original form. Thrilled, Richter initiated a full-scale scavenger hunt throughout Europe, eventually unearthing many parts of the original work. He was therefore able to create a new version that came very close to resembling Leonardo's actual intentions.

This new treatise includes many drawings and sketches to illustrate various points, and discusses key elements of Leonardo's art including perspective, light and shadow, colour theory, human proportions, as well as botany and landscape painting. It essentially comprises Leonardo's artistic theories and techniques, and for that reason has become one of the most sought-after art publications of all time.

Notable notebooks
Pearls of wisdom to be found within

Scattered throughout Leonardo's notebooks are to be found extensive writings on an amazingly wide variety of topics. These include architecture, anatomy, zoology, physiology, astronomy, time, water, boating, musical instruments and various fables and stories. Musings of particular note are on the subjects of architecture, human physiology and the natural world.

Leonardo may have intended to collect his copious notes on architecture, accompanied by detailed sketches, into a complete treatise on architecture. This would have put him in good company with the other famous architects of the day. Unfortunately he wasn't as careful with his architectural notes as he was with his ones on painting; the pages are scattered and less developed. It is however intriguing to discover that these architectural notes were in fact a mixture of reality and fantasy, containing both practical sketches of existing buildings, and experimental

Architectural studies

drawings of problematic architectural issues such as an explanation for the development of cracks in masonry.

Leonardo's notebooks clearly reveal his fascination with human development, in particular the process of conception from a medical standpoint and the development of a fetus in the womb. He didn't stop there though, but continued to study human development by chronicling the lives of people from infancy into teenage years. He studied the anatomical composition of muscles and bones, understanding that the body undergoes many transformations as it ages. To complete his work in this area, he

described human movement as a mechanical system of interlocking parts, claiming his place as one of the first to conceptualize this idea. His notes in this field demonstrate the amazing combination of engineering and medical knowledge Leonardo possessed.

Leonardo was a dedicated observer of the natural world. Throughout his notebooks, he made frequent references to water and even laid out plans for a book on the subject. He was incredibly thorough here and commented on everything from the ocean to rivers, and from conduits to canals. His notes also mention various geographical locations, many of which

Leonardo visited and surveyed himself. Was there anything he didn't do?

THE QUOTABLE LEONARDO

Leonardo's notebooks contain a number of philosophical statements and maxims. These pithy comments span topics such as religion, morality, science, mechanics, politics, speculation, spirits and nature. He also wrote a variety of jokes and other amusing stories, such as this one: 'It was asked of a painter why, since he made such beautiful figures, which were but dead things, his children were so ugly; to which the painter replied that he made his pictures by day, and his children by night.' (from The Complete Notebooks of Leonardo Da Vinci, *translated by Jean Paul Richter)*

Transfer of knowledge
Priceless treasures scattered

Since he had no wife or children, Leonardo chose to leave the bulk of his estate to his pupil, close friend and probable lover, Francesco Melzi. This inheritance included the remainder of his pension and, most notably, his notebooks. He also named Melzi the executor of his will.

Leonardo's last will and testament reads, in part:

'The aforesaid Testator gives and bequeaths to Messer Francesco da Melzo,

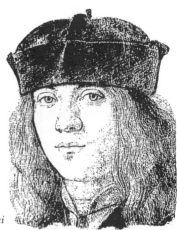

Francesco Melzi

nobleman, of Milan, in remuneration for services and favours done to him in the past, each and all of the books the Testator is at present possessed of, and the instruments and portraits appertaining to his art and calling as a painter.' (from wwww.gutenberg.org/dirs/etext04/7ldvc09.txt)

Scholars believe that Leonardo left at least 50, and perhaps as many as 120, notebooks to Melzi. Today only 28 survive and most of these are writings from around 1500 up until his death in 1519. After Leonardo died in France, Melzi brought the pages back to Italy with him, keeping them close by his side until his death in 1570.

When the notebooks were discovered after Melzi's death, their value was not recognized. To the untrained eye Leonardo's mirror writing had a tendency to appear as gibberish, mere nonsensical scribbles. Melzi's heirs certainly didn't help the situation, first leaving the precious documents to languish in an attic, then giving away or selling individual sheets with absolutely no idea of their true worth.

It was through this tragic combination of blunders and ignorance that Leonardo's notebooks came to be scattered throughout Europe. Many were eventually discarded, and some of the remaining pages show notes in the hands of others, meaning someone else (monks, perhaps) made their own notes on top of Leonardo's.

LAST OF THE ANCIENTS

Very little of Leonardo's scientific output was ever published or shared and this meant his discoveries had little impact on the progress of science. Scientific discovery and invention, from military engineering to human anatomy, proceeded in the slow, steady pace typical of history – unfortunately, it proceeded without the benefit of Leonardo's considerable intellect. Owing to his lack of influence on other scientists Leonardo is sometimes labeled as the 'last of the ancient scientists'. This term is used to describe historical scientists who worked in isolation as deemed by the technological and political limitations of their day. In today's world the progress of science is much

more collaborative, and if Leonardo had been working in our age there is no doubt that his story would have been very different.

Decoding the codices
Keeping the record straight

Approximately 5,000 pages of Leonardo's notes still exist today. Originally written on loose sheets of paper, many of these manuscripts have been bound over the years into special volumes known as codices. Each volume has a name, and it's easy to identify which particular sheet belongs to which codex. However the modern arrangement of the codices is somewhat haphazard, and it is highly probable that the current volumes bear no resemblance to the actual order in which Leonardo wrote them.

Perhaps the person most responsible for this erratic mess was Pompeo Leoni, a sculptor at the royal court of Spain in the late 16th century. Leoni collected many of Leonardo's writings, but in trying to organize them he cut and pasted pages from various notebooks and arranged them into separate volumes divided into artistic, technical, and scientific sections. Leoni's method destroyed the original order, but at the same time did provide a convenient cataloging system. From Leoni's efforts sprang the *Codex Atlanticus*, and the so-called Windsor collection.

Codex Atlanticus

The *Codex Atlanticus* currently resides in the Biblioteca Ambrosiana in Milan. The largest and most notable of the codices, it contains hundreds of sheets of Leonardo's original notes that mostly date from between 1480 and 1518. The codex was donated to the library in 1637, but was taken to Paris along with other notebooks when Napoleon conquered Milan in 1796. There, the notebooks were kept in the National Library of Paris and the Institute of France until 1851 when the *Codex Atlanticus* was returned to Italy.

Primarily, the *Codex Atlanticus* contains the technical, mechanical and scientific drawings from different notebooks, while the artistic, natural, and anatomical drawings are part of the collection at Windsor.

Codex Arundel

Leonardo's other codices are located all over the world and one particularly fascinating volume is housed in the British Library. Recognized as second in importance to *Codex Atlanticus*, *Codex Arundel* received its name from the Earl of Arundel who purchased it in Spain in the 1630s. Consisting of 238 pages, Leonardo wrote amongst the notes in this volume that he began collecting various comments and sketches into one place that he wished to later organize according to subject. Of course, he never actually got around to finishing the project. Leonardo started the collection in 1508 while he was living in Florence and like most of Leonardo's other codices, this one was put together after his death from sheets of various sizes. The subjects cover everything from mechanical designs to studies on the flight of birds.

Pretty as a picture
Celebrated portrait painter

Leonardo was an incredibly sought-after portrait artist in his time, and his particular ability to capture not only the likeness but also something of the personality and spirit of the sitter only served to increase his popularity further.

Leonardo painted a number of female portraits during his early years, including *Ginevra de' Benci* in 1480 and *La Belle Ferronniere* in 1495. The portrait of Ginevra de'Benci is one of his earliest completed and preserved works, and clearly demonstrates his unique approach to portraiture. Leonardo illustrated his portrait subjects with a touch of realism that was rare in the Renaissance; most of his contemporaries tended to follow the safer route of fantastical flattery. Subsequently the subject of *Ginevra* has a less-than-flattering expression on her face that can only be truly described as almost grumpy.

Leonardo's celebrated *Mona Lisa* is a masterpiece of portraiture by capturing the subject's essence so unforgettably. Leonardo's technical

Grotesque Head

painting abilities helped him make this sitter appear unfathomably real, but her eyes, mouth and other facial features also give her a unique aura of mystery that is rarely captured successfully in a painting.

Leonardo did paint male portraits as well, but not nearly so many. One well-known male study is the *Portrait of a Musician* from 1483, which is also one of his best-preserved paintings. Ironically very little is known about it – it is not even clear who the sitter is. Some historians believe it to be Ludovico Sforza, Duke of Milan,

while others claim the subject to be Franchino Gaffario, Milan's most famed choirmaster.

CAPTURING THE GROTESQUE

In addition to portraits – and in stark contrast to his favoured subjects of angels, Madonnas and other figures of extraordinary beauty – Leonardo also started to complete a number of pen-and-ink caricatures in the 1490s, most of which illustrate grotesque, distorted facial features. Leonardo's first biographer Giorgio Vasari has addressed this dimension of Leonardo's work, noting that the artist was fascinated by what he described as 'odd' people. According to Vasari, Leonardo would often follow these people as potential subjects for his 'grotesque' sketches, committing their unconventional features to memory. One of the most unusual of these portraits is Leonardo's Grotesque Head *chalk drawing of 1504. The original is nearly life-sized and ultimately seems to have started a trend – other painters around Europe soon began creating their own versions of the grotesque.*

Leonardo's exaggerated sketches were undoubtedly some of the world's first caricatures, and it is possible that these drawings also provided one of the earliest foundations for modern-day political cartoons.

Mirror image
Self-portraits of the master

Most famous artists have painted at least one self-portrait – indeed Goya, Rembrandt, Durer, Van Gogh and others chose to focus primarily on painting self-portraits. While Leonardo was busy with a plethora of tasks, he did create several self-portraits over the course of his life that, from a pre-photographic world, provide some insight into his more personal side. Who isn't curious about what the great genius actually looked like?

Leonardo's self-portraits are not pretentious and formal. One of Leonardo's best-known self-portraits, dating to about 1512, contains his own annotations and was rendered in red chalk on paper. In this drawing he has a full, flowing white beard and is clearly aging in years. Leonardo may have created several other sketches of himself, although it's now difficult to confirm that he did actually draw them himself.

One example is a sketch named *Old Man Sitting.* Most likely dating from the late 1400s, it appears to show Leonardo sitting on the bank of the River Loire in France. Another

Verrocchio's David sculpture

sketch is *Profile of a Warrior in Helmet,* a silverpoint drawing Leonardo prepared in 1472. Given the time period in which Leonardo created this work it is possible that the subject of this drawing was actually one of Verrocchio's models, although some historians believe that it was indeed a self-portrait of the artist.

PUTTING HIMSELF IN THE PICTURE

In addition to these standalone self-portraits, it is fascinating to discover that Leonardo actually included himself in several of his most famous paintings. One of the best examples is his Adoration of the Magi, *into which most historians believe he painted himself as one of the shepherds. The figure believed to be Leonardo is the shepherd facing away from the main crowd, in the bottom right-hand corner of the painting. While Leonardo enjoyed painting himself, he also extended this privilege to others, and at various points in his life Leonardo posed as a portrait model. Verrocchio most likely based his 1466 sculpture of* David *on young Leonardo, and Raphael in*

all probability used Leonardo as the model for Plato in his 1510 painting The School of Athens.

To cut a long story short
Leonardo's fabled fables

As well as writing copious notes on the various topics he studied, Leonardo also turned his hand to writing fiction, composing a number of fables intended to illustrate a particular moral point that have been found scattered throughout his notebooks. Many of Leonardo's tales involve intelligent animals, perhaps another indication of his love and fascination for the natural world.

Leonardo was by no means a writer of epics. Instead, he dabbled in fiction, gracing his readers with a number of short stories. It is not clear whether Leonardo wrote them all himself – some might be stories that friends of Leonardo wrote in his name, or stories that Leonardo recorded after hearing someone else tell them. In any case, from the evidence historians can gather, Leonardo wrote at least 30

stories and illustrated most of them.

Many of these stories are still told today, and most people are not even aware that the great Leonardo da Vinci penned them – they are simply known as Italian folk tales, beloved by children and adults alike.

The Spider and the Grapes

One of Leonardo's famous fables was that of *The Spider and the Grapes*. A clever spider, seeing how bees and flies feasted on the sweet grapes of the vineyard, decides to spin its web close to the grapes. The insects would become stuck in the web, and the spider would have a meal.

One day, the owner of the vineyard cuts down this particular grape stem. The flies are rescued from their certain doom while the spider is punished for his trickery. Like most of Leonardo's stories, there is a definite moral here – preying on the innocent leads to no good.

The Goldfinch

A fable close to Leonardo's heart is *The Goldfinch*. A mother goldfinch returns to her nest one day to find all her babies missing. She eventually

discovers them caged outside a farmhouse window. Try as she might, she can't open the cage.

The next day she returns to feed her babies through the bars, but they die soon after because their mother has fed them poisonous berries. Her final words are, 'Better death than loss of freedom.' Perhaps Leonardo felt that if artists could not be free to paint as they wished, then they shouldn't paint at all.

Singer songwriter
An outstanding performance

Music played a vital role in Renaissance culture and no self-respecting court entertainment was complete without musical pageantry and performance. Naturally, Leonardo was both an innovator of new musical instruments and an accomplished musical performer.

As a child Leonardo showed an early interest in a diverse

Viola da gamba

range of musical activities. Apparently he was a good singer and liked to spend evenings entertaining friends and relatives. He also taught himself to play the ancient stringed instrument called the lyre, and was known for making up his own songs, complete with rhyming lyrics, on the spur of the moment.

During his years under the patronage of the Sforza family, Leonardo was regularly known to play the lyre for Ludovico Sforza. For the celebration held in honour of Ludovico's rise to dukedom, Leonardo performed on a special lyre he had made himself. It was silver and designed in the shape of a horse's head, a spectacular innovation since most lyres of the day were of a simple wooden design.

His performance was rumoured to have surpassed that of any of the court musicians, endearing Leonardo to the royal family – but perhaps not to the musicians. Stories of this performance even prompted Michelangelo, one of Leonardo's biggest rivals, to refer often to Leonardo as 'that lyre-player from Milan.

MUSIC BY DESIGN

Some historians believe that Leonardo not only played instruments but also to helped design them, in particular a predecessor to the violin called the viola da gamba. *During his lifetime Leonardo built several string instruments, and his notebooks indicate a keen interest in studying their acoustic properties. Leonardo's studies in sound, tone and related instrumental properties surely had some influence upon the artists who would go on to develop the violin, cello, and other stringed instruments. Gasparo da Solo (1542–1609) was the creator of some of the very first violins and while da Solo was born after Leonardo's death, Leonardo may well have known and worked alongside da Solo's father.*

School of Leonardo
Teaching his tricks of the trade

L eonardo never established a formal school to teach his methods, however he did instruct plenty of apprentices and students

in his studio over the years. During his years in Milan at the court of Ludovico Sforza he had a number of apprentices and students, and even wrote a series of training manuscripts specifically for them that were later collected into book form as *A Treatise on Painting*. Leonardo collaborated on a number of works with his students, and it still remains unclear exactly who created the various works that came from his studio during this period.

Leonardo's pupils during this first Milan period included:

GIOVANNI ANTONIO BOLTRAFFIO (his earliest pupil)
BERNARDINO DE'CONTI
GIACOMO CAPROTTI (nicknamed Salai)
GIOVANNI AGOSTINO DA LODI
ANDREA SOLARIO
AMBROGIO DE PREDIS
FRANCESCO NAPOLETANO
MARCO D'OGGIONO

When Leonardo was in Milan again in the early 1500s, Bernadino de'Conti and Salai continued in their apprenticeship and were joined by a

The Virgin and the Child *by Giovanni Antonio Boltraffio*

new crop of students, including:

BERNARDINO LUINI
CESARE DE SESTO
GIAMPETRINO
FRANCESCO MELZI

Although Leonardo's students spent much of their time working alongside their master and copying his work, few of them ever transcended his direct influence to become well known in their own right. It would appear that Leonardo had a tendency to choose his assistants for their good looks rather than their artistic abilities.

One student who did show talent was Giovanni Boltraffio, one of Leonardo's earliest students after he moved to Milan in 1482. Leonardo probably used Boltraffio as a test case for his teaching, and it seems to have paid off. Leonardo's training is visible in many of Boltraffio's works, including his 1495 painting *The Virgin and the Child,* a work he may have based on Leonardo's sketches.

Later in Leonardo's life, during his final years in Rome between 1509 and 1516, he continued to instruct many students. In fact Leonardo's students copied his final painting, *St John the Baptist*, many times. Since many of Leonardo's original works are now lost, it is only the copies completed by his pupils that allow us to appreciate the full gamut of his work.

Healthy competition
Rivalry with Michelangelo

Renaissance Italy was a hive of innovation and artistic talent, and Leonardo's considerable talent was certainly not without rivals. The most famous of these was probably Michelangelo Buonarroti (1475–

1564), one of the major artistic forces of the Renaissance and creator of the celebrated sculpture *David* in 1501. These two extraordinary legends competed for a variety of projects in an extremely healthy competition, never known to sing each other's praises in private or public.

While they knew each other by reputation, it appears that Leonardo and Michelangelo may not have crossed paths until 1500 in Florence. However the two men had much in common – they were two of the most celebrated artists and architects of the day, and various influential rulers recognized their fame. Both created works of historic proportions, and both were prolific with their skills. Additionally, they were both leading the way in terms of anatomical research; their representations of people and animals were far superior to those illustrated by most of their contemporaries.

Leonardo and Michelangelo had at least one project in common. In 1503 both artists won commissions to paint murals on the walls of the Palazzo Vecchio in Florence. The theme of these murals was to be

the city's glorious military victories. Leonardo's resulting commission was for a representation of the Battle of Anghiari, a scene in which the Florentine army defeated the city of Pisa. Leonardo completed sketches for this painting, but the painting itself suffered from yet another of Leonardo's painting innovations that backfired and nothing remains of it today. Michelangelo's mural was to have represented the Battle of Cascina, but his also only remains in cartoon form since Pope Julius II called him away before he was able to create the actual painting. It would seem that the project was cursed from the outset.

It was by no means all peace and love in the Renaissance art world. There was rumour that Michelangelo may have mocked Leonardo about his failure to realize the massive equestrian statue of Francesco Sforza. It also appears that Michelangelo might have made further disparaging comments about Leonardo over the years and while the real source of these comments is unknown, it is fair to assume that these two Renaissance greats always considered each other far more rivals than friends.

GREAT MINDS THINK ALIKE

In The Last Judgement, *a quintessential Renaissance painting, Michelangelo manages to incorporate a cleverly disguised self-portrait. This was a common trick that Renaissance artists employed as a way of infusing their paintings with a more personal touch, and it's one that Leonardo also embraced. Great minds truly do think alike.*

David *by Michelangelo*

His own personal giant
Complementary Titian

Leonardo spent most of his career working in Milan and Rome. Tiziano Vecellio (1490–1576), or Titian as he was better known, was another artistic hero of the Renaissance and became the city of Venice's major player.

Today the popular view is that Titian's work complements Leonardo's, together creating a completely rounded picture of artistic progress and achievement during the Renaissance. Although the two men may not have met during their lifetimes these two giants, with a little help from their friends, created the panorama of Renaissance art that has been recognized and admired ever since.

As with Leonardo's, Titian's early works also show a symbiosis between highly stylized landscapes and a humanlike God. Titian continued this theme in 1518 when he painted his famous bacchanalia scenes for the palace of the Duke Alfonso d'Este. One painting from this series entitled *Bacchus and Ariadne* is especially representative of Titian's style – bright colours separate the figures in the scene, and the unbridled wildness of Dionysus and his followers is perfectly captured. Titian is perhaps best known for this series of paintings as he was one of the first to illustrate the revelry of bacchanalia in a distinctly Renaissance Humanist setting, combining sensational daring with an amazing show of skill.

Besides paintings of frivolity set in the countryside, Titian painted a number of religious scenes. *The Assumption of the Virgin* (1516–1518) was one of his first works that was clearly non-Venetian in nature, thereby enhancing his credibility with guildsmen and patrons from other Italian city states. The force and tension in the scene became a distinguishing characteristic of Titian's work at the time. As he moved further into his career, Titian's paintings began to reflect a calmer atmosphere. *The Venus of Urbino* (1538–1539) conveys an intimacy seen only rarely in other works; Leonardo's *Mona Lisa* is a comparable example of the emotional warmth and mystery that can be conveyed through painting.

Toward the end of his life Titian's style changed once again. His later works such as *Rape of Europa* (1559–1562) and *The Flaying of Marsyas* (1575–1576) show an increasing formlessness; shapes blend together and his scenes, though representative, become more abstract. His lifetime's work displays a distinct progression that is not as apparent in the more characteristically consistent portfolio of Leonardo.

CUTTING EDGE COLOUR

An interesting note is that Titian's use of colour was often more dramatic and cutting edge than Leonardo's. Working with Venetian raw materials, Titian developed both bright and dark colours that truly captured and held the viewer's attention. One of his shades of auburn is so original that it is known today as, simply, 'titian'.

Fellow Florentine
Botticelli on a half-shell

Alongside Leonardo, the other major Florentine artistic force was the great Sandro Botticelli (1445–1510). Botticelli spent a period working in the studio of Leonardo's master Andrea Verrocchio – in fact, Leonardo and the older Botticelli probably studied alongside each other for a time. Botticelli learned much from the teachings of Verrocchio, evident in several aspects of Botticelli's painting. In particular, Botticelli learned an aggressive style he used to represent motion, flight and the elements simultaneously, techniques that would serve him well in creating his future hallmark paintings.

By the time he was 25 years old Botticelli ran his own workshop in Florence. While Leonardo worked for various rulers over the course of his life, Botticelli found his own way by aligning himself predominantly with the wealthy, powerful Florentine families such as the Medici. He had a better reputation for finishing his projects than Leonardo that probably meant he didn't have to consistently

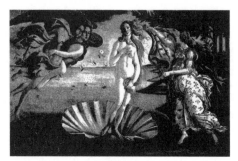

The Birth of Venus *by Botticelli*

seek alternative employers. One of Botticelli's most famous portraits was of Giuliano de Medici and is thought to be the most accurate painting of this powerful Renaissance figure that remains in existence.

In 1482 Botticelli created his best-known painting *The Birth of Venus*. One of the most iconic images of the Renaissance, it is studied in virtually every art history class in the world today. This amazing piece shows Venus standing on a shell as she rises from the ocean waves. Venus was the ancient goddess of love, renowned for her breathtaking beauty, and Botticelli rendered her with an extraordinary grace and elegance that ensured his place forever as one of the true Renaissance greats.

A major difference between Botticelli and Leonardo can be found in their travels (or lack thereof). Leonardo spent many years travelling between different cities, earning the respect and admiration of the clergy and powerful families as he travelled. He observed people from many walks of life, discovering the music and culture of his international contemporaries. Botticelli, on the other hand, was content to stay in one place. He did not seem to share the restlessness that affected his counterparts, and while he may have missed out on a more multicultural experience, he displayed a particular single-mindedness that is evident in the style and subject matter of his incredible legacy.

Literary prince
Machiavelli, friend and business partner

Artists did not carry the entire weight of the Renaissance upon their shoulders – poets, philosophers, historians, playwrights and authors

also had their own unique parts to play. Niccolo Machiavelli (1469–1527) was one such poet-philosopher from Florence who rose to sensational notoriety.

Machiavelli is best known for his work *The Prince*, written in 1513 as a critique of Renaissance politics. According to his treatise, the powerful Italian ruling families were essentially modified versions of Attila the Hun, instigators of invasions, attacks and general unbridled corruption. Some historians believe that this treatise was based on the life of Cesare Borgia, the powerful yet cruel warrior ruler with whom Leonardo had travelled for many years.

In *The Prince*, Machiavelli also tried to define rules for the politician – how to gain power, and how to keep it. *The Prince* was met with widespread public outrage. Many believed Machiavelli was cruel and harsh in his judgements, most of which were in actual fact probably very close to the truth. Machiavelli was ousted from his beloved Florence several years later, primarily due to ongoing negative public opinion surrounding his infamous treatise.

Leonardo was rumoured to have been friends and business partners with Machiavelli. They probably met whilst working with Cesare Borgia – Leonardo was travelling with Borgia between 1500 and 1506, and Machiavelli went to study his army sometime during the early 1500s. Both men were intensely patriotic, and both considered Florence their home. Although their professions were markedly different, their perspectives on Renaissance Humanism were remarkably compatible.

WORKING TOGETHER
In 1503 Leonardo and Machiavelli collaborated on Leonardo's sensational scheme to re-route the Arno River, an ambitious plan that, had it reached fulfillment, would have seen Florence establish a completely new identity as a bustling seaport. Moreover Leonardo and Machiavelli shared another common project in Florence – the depiction of the Battle of Anghiari. Although Machiavelli helped Leonardo to obtain this commission, their recordings of the

event differed. Leonardo's painting shows the success of Florence in claiming this medieval town from its Italian rivals; Machiavelli, on the other hand, writes of Florentine confusion in battle and the city's less-than-able armies. While Leonardo may have taken artistic liberties with his patriotic rendering, his freedom of expression complements Machiavelli's more factual recounting and both portrayals were vital in recording this battle for history.

Niccolo Machiavelli

The gentle man
Profile of an artist

Leonardo was a genius, evident from the plethora of artistic and scientific achievements he made during his lifetime. However what was this genius really like on a personal level? Exploring Leonardo's profile throws up some fascinating facts that provide a greater insight into this extraordinary individual. He was an animal lover and a vegetarian, he was remarkably strong and handsome in his youth, and he was a kind, considerate humanitarian.

Leonardo had a remarkable compassion and fascination for animals. He sketched and painted from nature frequently, studying animal movement closely to achieve accurate representations in his art. Later in life he performed animal dissections, learning even more about their anatomical systems. In particular he seems to have felt an exceptional kinship for caged animals, and as an adult he was often known to purchase cages filled with trapped animals simply to set these prisoners free.

In keeping with this deep

compassion for animals, Leonardo was a vegetarian most of his life. His notebooks and other writings even contain vegetarian recipes and he mentions several well-known vegetarian chefs by name, for example Bartolomeo Platina (1421–1481). Common vegetarian fare for Leonardo would have centred on vegetables and pasta, enhanced with innovative combinations of herbs and spices for flavour.

During the Renaissance fine looks were important. Artists who were easier on the eye were far more likely to secure patronage than those who weren't – equitable or not, powerful families of the day preferred to fill their courts with fine-looking craftsmen. Leonardo was allegedly one of the most handsome painters of his day and his fine looks served him well. He made friends easily and had little trouble finding work. His physical appearance has been contrasted favourably to that of his intense rival Michelangelo who was, it seems, considerably less good-looking.

Generally speaking, Leonardo was regarded as a humanitarian. He was not known for fits of temper, and despite his inability to finish many projects he was easy to work alongside and enjoyed collaboration. He was also kind to his servants and remembered several of them in his will. Leonardo was probably the sort of person who would have made an excellent friend – loyal, kind and considerate.

THE LOVE OF HORSES

Leonardo was particularly fond of horses. At the time these animals were vital commodities that played essential military and civilian roles, and Leonardo designed elaborate stables with archways and ventilation systems to house these beasts. Leonardo took great pride in the appearance and comfort of his animals; he believed they were individual creatures that deserved the same comfort and humane treatment as people.

Personal accusations
A gross invasion of privacy

Palazzo Vecchio, Florence

Some people write tell-all memoirs, while others keep their private lives to themselves. Leonardo was without a doubt of the latter inclination and preferred to keep his personal life intensely private. Although thousands of pages of his writings survive, he mentions almost nothing about his innermost thoughts and feelings. It is now believed that this predilection could date from a gross invasion of privacy that occurred at the very beginning of Leonardo's professional career.

In 1476 the 24-year-old Leonardo was still officially a member of Verrocchio's studio, but was beginning to take outside commissions. On 8 April 1476 an anonymous accusation was deposited in a wooden box, which had been positioned for this purpose, in front of the Palazzo Vecchio in Florence. Leonardo and three other young men were accused of having a homosexual affair with male model and suspected prostitute, 17-year-old Jacopo Saltarelli. A second anonymous accusation against

Leonardo was deposited in the same box on 7 June of the same year.

On the whole 15th-century Italy was not a liberal society. In artistic Florence homosexuality was common and not particularly stigmatized; the authorities usually tended to ignore such conduct. However homosexuality in Renaissance Italy was technically a criminal offense, and once formal charges were made they had to be prosecuted. Leonardo and the others were accordingly taken

into custody by the authorities and held for two months. The charges were eventually dropped due to lack of conclusive evidence and witnesses, and all four men were released. This acquittal was conditional, however; it only applied if Leonardo and the others were never again subject to a similar accusation.

Perhaps because of this accusation there is no record of Leonardo's work or even his whereabouts from 1476 to 1478, although it is assumed that he remained in Florence. However Leonardo appears to have recovered his equilibrium by 1478, for it was in this year that he received his first official commission in the form of the *Adoration of the Magi*. This work, while never finished, set Leonardo on his way to becoming an acclaimed artist.

A VERY PRIVATE LIFE
While Leonardo appears to have put the ruckus over the accusation of homosexuality behind him fairly quickly, it is likely that it remained an influence on him for the rest of his life. Leonardo's intense privacy about personal matters most probably dates from this period and the artist may

have eventually left his beloved home city of Florence to escape unpleasant memories of the incident.

Just good friends?
Long-term relationships

Leonardo was no Casanova; in fact, he had no known relationships with the fairer sex. He did however enjoy the company of two long-term relationships with men during his lifetime.

Salai
Gian Giacomo Caprotti da Oreno, his first companion, was brought into Leonardo's household in 1490 when he was at the tender age of ten years old. It is not clear whether his arrival was as an adopted son, an art student, a servant, or an intimate companion, yet his status in the da Vinci household seems to have undergone several transformations during his lifetime. Given the indulgence that Leonardo showed him, and the length of their relationship, it does seem evident that he was much more than just a common servant.

Salai

Giacomo was quickly nicknamed Salai, meaning 'little Satan' or 'devil', and the fellow certainly lived up (or down) to this name. Leonardo's notes describe his early antics, especially his repeated thieving. Salai began stealing from Leonardo as soon as he moved in and continued to do so at every given opportunity. It seems highly unlikely that Leonardo would have put up with such behaviour from a mere apprentice or servant.

Leonardo attempted to teach Salai to paint, but the young man does not seem to have been particularly talented in this area. Under Leonardo's tutelage he did produce a few paintings which Leonardo himself is rumoured to have retouched. However the affection between the two men appears completely genuine and Salai remained with Leonardo for over 25 years, until almost the end of Leonardo's life. In his last will, Leonardo left Salai a house and half his vineyard.

Undoubtedly a large part of Salai's appeal, as well as his apparently indomitable spirit, was his beautiful appearance. His long, blonde curls were a favourite with Leonardo and a number of his sketches of Salai show off these fine features. Indeed Salai was likely the model for the young man in Leonardo's *Portrait of an Old Man and a Youth*.

Melzi

Leonardo's second long-term companion was Francesco Melzi, a minor noble from Florence who joined Leonardo's household in 1505 at the age of 15 years old. Supposedly Melzi was also a very handsome young man, like Salai. Unlike Salai, Melzi does appear to have been a more talented painter and definitely less of a handful. A

number of paintings and drawings by Melzi survive, including a portrait of Leonardo. Clearly, Melzi had only minor talent when compared with his master painter.

Melzi remained with Leonardo until Leonardo's death, upon which he became the executor of Leonardo's will. Leonardo left the bulk of his estate to Melzi, including his clothes, the paintings he still possessed and, perhaps most significantly, his notebooks. Melzi faithfully kept these notebooks safe until the end of his life around 1570, and is thought to have organized some of them into a longer version of *A Treatise on Painting*.

Although no direct evidence exists to prove that Leonardo and Melzi had a sexual relationship, the fact that Leonardo named Melzi as his heir and left his precious notebooks in Melzi's care indicates the deep love and trust he felt for his former student.

Was he or wasn't he?
A debate on sexuality

Many aspects of Leonardo's life indicate that he was most likely homosexual, although there is no conclusive evidence of this. In addition to his long-term relationships with male friends Salai and Melzi, there are other indications of Leonardo's sexual orientation throughout his life and work. Leonardo never married, and is never recorded as having shown any non-professional interest in women whatsoever.

Maybe some evidence of Leonardo's views of the female sex can be discovered in his drawings. His anatomical sketches include both male and female genitalia, but while the drawings of male sexual organs are detailed and accurate, the female genitals are much less so. Perhaps

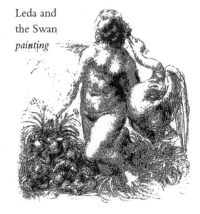

Leda and the Swan *painting*

Leonardo had more ready access to male models than to female ones? Leonardo drew both male and female nudes but again there are fewer female drawings and these contain far less detail. Unlike other Renaissance painters who were far more prolific in their renderings of the female body, Leonardo produced only one formal painting of a female nude, namely *Leda and the Swan*.

In spite of Leonardo's evident preference for illustrating the male figure, he did not always portray his men as intensely masculine. In Leonardo's famous work *The Last Supper* St John appears extremely effeminate, even somewhat androgynous. Leonardo's notebooks show many drawings of beautiful young men, often with cascades of curly hair and sultry eyes. Many of his more erotic sketches appear to show hermaphrodites or androgynous figures – one in particular, dubbed the *Angel in the Flesh*, shows a figure with a feminine face and chest, but with otherwise distinctly masculine features.

It is also fascinating to discover that Leonardo expressed a distinct distaste for male-female sexual intercourse in his notebooks. A famous quote from the same reads:

'The art of procreation and the members employed therein are so repulsive, that if it were not for the beauty of the faces and the adornments of the actors and the pent-up impulse, nature would lose the human species.'

The lack of documentary evidence of a relationship between Leonardo and a woman, combined with his long-term relationships with two handsome young male students and his obvious dislike for heterosexual relations, suggests that Leonardo preferred men to women. Historians will never know for sure, but the answer seems likely.

BEAUTIFUL MEN
Leonardo's final painting St John the Baptist *was one of the few artworks that was in Leonardo's possession when he died and it was likely a personal favourite. The painting was created during Leonardo's last years in Rome, between about 1509 and 1516, and travelled with him to France.*

Leonardo had painted St John as almost female in appearance with his trademark long curly hair, and it is fascinating to see that the saint's beautiful smile bears a striking resemblance to that of Mona Lisa.

On the analyst's couch
Sigmund Freud on Leonardo

Leonardo was a genius with his fair share of oddities and eccentricities; in these he could be deemed a psychoanalyst's dream. Certainly famed neurologist and psychotherapist Sigmund Freud (1856–1939) found Leonardo utterly fascinating and conducted a thorough study of his life, using the contents of the Leonardo's extensive notebooks to try to establish what made him the genius that he was. With Freud being – well, Freud – the analysis was destined to be of a sexual nature.

Freud became deeply engrossed in the life of Leonardo and carried out a comprehensive study of the Renaissance master in 1910 entitled *Leonardo da Vinci and a Memory of His Childhood.* As was his custom

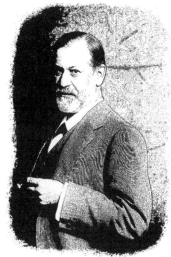

Sigmund Freud

Freud studied mainly Leonardo's sexuality, reaching the conclusion that Leonardo displayed homosexual tendencies because he had spent most of his childhood in male company. His also theorized that Leonardo had in fact idolized and desired his mother, making a relationship with another female unthinkable and thereby leaving homosexuality as his only recourse.

While homosexuality was common during the Renaissance, its practice was a crime that could be punishable by death. Freud's further opinion

was that Leonardo's many unfinished projects were a result of the sexual tension the artist experienced as he found himself unable to fulfill his sexual desires in public.

This seems like a somewhat tenuous excuse for not finishing a project and Freud's theories are inconclusive at the least. The main value that can be drawn from this study is that it was the first comprehensive attempt to understand Leonardo's sexuality. Since the subject wasn't discussed openly during Leonardo's lifetime, there exists no improved information on the subject. If nothing else, Freud's work was the catalyst to allow this very discussion to take place.

Skill overload?
Polymath in good company

L eonardo's genius is undeniably conclusive. He was a skilled artist, architect, inventor, scientist and geometrician. From performing anatomical dissections to attempting to re-route rivers, his interests and skills were wildly diverse. But is it possible to argue that he actually had too many gifts?

Many of his projects went unfinished, and many of his skills could have been further developed. For example, if Leonardo had focused on his painting he may well have finished more of his stunning works. But because Leonardo was good at so many things besides painting, he simply was not able to focus on this one skill.

Instead Leonardo chose to spend time on each making him what is known as a polymath, or someone who has extraordinary talent in myriad areas. Leonardo the polymath was in good company – other geniuses throughout history exhibiting similar characteristics include Sir Isaac Newton, Benjamin Franklin and Thomas Edison.

COMPARISON TO EINSTEIN
Albert Einstein (1879–1955) is considered one of history's greatest geniuses and perhaps the greatest scientific mind of the 20th century. Celebrated for his theories that revolutionized the study of space and time, he developed the General and Special Theory of Relativity, which

showed that space and time were not absolute as had once been believed by Leonardo and other famous scientific predecessors. Similarly to Leonardo, Einstein had varied interests, although probably not quite as far ranging. Also like Leonardo, Einstein enjoyed music – Leonardo had his lyre while Einstein treasured his violin. Most importantly perhaps, both geniuses based their scientific theories on simple observations made with little equipment.

Flawed genius
Everyone makes mistakes

The old saying is true – everyone makes mistakes. Being human, Leonardo was no exception. His mistakes were however exceedingly rare, making them stand out all the more in his otherwise superb track record of achievements.

Some of Leonardo's errors were simply due to lack of information. The precise nature of human anatomy was only starting to be understood in the 15th century. Leonardo performed dissections on cadavers

and made careful studies, but he had no formal medical training and was likely missing critical pieces of the biological jigsaw. For example, Leonardo made several sketches of a woman's womb complete with uterus, fetus and umbilical cord. However he misjudged the size and shape of the placenta, the resulting illustration resembling more closely the placenta of a cow than that of a human.

Similarly, Leonardo occasionally championed popular but

Drawing of Isabella d'Este

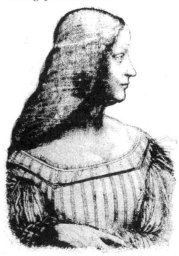

flawed theories. He was a fan of physiognomy, the supposed art of judging a person's character from his or her facial features. Barthelemy Cocles first published this theory in 1533 and in the 19th century physiognomists used it to try to predict who would be a murderer or thief. Sounds dangerous, doesn't it? Of course the concept was fundamentally flawed and had no basis in science. In this case Leonardo had committed an error in judgement, but he was by no means alone in his ignorance – incredibly, physiognomy was held as a valid analytical tool until the 20th century.

One of Leonardo's more technical errors was in his design for a military armoured tank. On a closer examination of his wheel system underneath the carriage it becomes clear that the wheels would have actually been turning in opposite directions, spinning harder and faster until the entire machine collapsed in a heap of metal and smoke.

At first glance it seems the occasional flaw may have also crept into Leonardo's art. His drawing of Isabella d'Este from 1500 shows some of the figure, notably the arm, out of proportion; the musculature is also incorrect, and the figure does not seem lifelike. However Renaissance artwork was often done collaboratively and works that have been subsequently attributed to Leonardo may have actually been rendered by his students. Given Leonardo's in-depth knowledge of, and careful attention to, anatomical detail, it seems likely in this case that one of his students made the mistakes. Indeed the vast majority of Leonardo's artwork was of superb quality and highly accurate.

True believer
A devout Christian?

Many of his paintings are religious in subject matter and Leonardo even worked for the Pope for a time. But what did Leonardo actually think of religion? Was he a true believer, or was he just another sheep hiding in the flock? Most scholars now believe that Leonardo was indeed a devout Christian, despite evidence that might suggest otherwise.

Madonna and Child with a Pomegranate

Little has been discovered regarding Leonardo's religious upbringing. His grandfather arranged for his baptism, and the church of Santa Croce in Vinci is said to house the font where Leonardo was baptized. This fact alone supports the possibility that he was indeed raised in the Christian tradition. Some of Leonardo's early training may have come from local priests, but that is only supposition. Given that Leonardo's grandfather appears to have been a religious man it can be assumed that his father was

at least nominally Catholic, while his mother would most likely have been either Catholic or Jewish.

We do know that Leonardo wasn't averse to painting biblical subjects. Many of Leonardo's paintings were of a religious nature – *Baptism of Christ, Annunciation* and *Madonna and Child with a Pomegranate* are just a few examples of the religious themes Leonardo was commissioned to paint. Given the time and place however, he would have had little choice in this – religion, power and culture overlapped significantly during the Renaissance, and a patron would have been obliged to support the faith by commissioning his artists to create astounding works of religious art.

While not an out-and-out heretic, Leonardo did act in ways that could be deemed free thinking. The fact that he may have included images of himself in several of his paintings (including *Adoration of the Magi* and *The Last Supper)* had the potential to severely irate the religious orders, since the inclusion of mere mortals in scenes of holiness was considered highly inappropriate. However Leonardo did spend much of his life

working under the Pope's influence and his frequent engagement with the clergy no doubt persuaded him towards the Catholic tradition.

LAST RITES

It appears that Leonardo did believe in God and the Catholic tradition. His writings refer to God as the creator of the universe and the heartfelt spirit of his religious paintings surely reveals his devotion. Although Renaissance Humanism promoted the spirit and ability of man, it also tied man's development to ongoing worship and religion, and Leonardo fully embraced all these aspects of the Renaissance. Leonardo's will made provisions for a Mass to be said in his honour with candles to be lit in a number of churches. This act confirms that he was in alignment with the Christian religion to the end. Furthermore upon his deathbed Leonardo repented for his sins and asked to be instructed in the last rites of Catholicism. It seems he felt that he had much to repent for, but ultimately professed his commitment to God.

Artistic license
Eccentricities enhance his mystique

The creative mind doesn't always follow convention and society has always treated its creative folk with indulgent leniency. Many artists are known for their eccentricities and Leonardo was no exception. He exhibited several oddities in his mannerisms and art, none of which seriously detracted from his fame or popularity – in fact they may have even added to his mystique.

In his handwriting

In contrast to most Western styles the sentences in Leonardo's notebooks are written mostly from right to left, with the letters also written backward. This means that the easiest way for the untrained observer to read one of his manuscripts is to hold it up to a mirror. Leonardo also made up his own spellings for some words, and wasn't particularly fond of punctuation.

In his art

Leonardo's eccentricities extended beyond his handwriting style and into his art. He often took artistic liberties

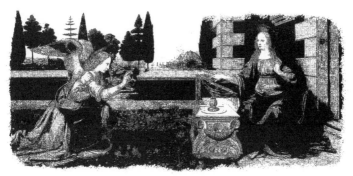

Annunciation *painting*

in his paintings that would have been unthinkable for the more traditional artist. Leonardo was, in his own way, a risk taker. While he kept up a certain amount of convention in order to keep his patrons content, he seems to have bent the rules whenever possible.

For instance in his painting *Annunciation* the wings of the angel resemble those of a bird more closely than those of a traditional angel. Leonardo may have simply wished to experiment, but the result is that the wings seem oddly discordant in this otherwise traditionally religious scene.

This unconventional design would definitely have made *Annunciation* something of an oddity when placed in context with other Renaissance art. Yet although eccentricities of this sort

might have been intolerable for lesser artists, in Leonardo's case they only seemed to serve to increase his appeal.

State of mind
A 20th century diagnosis

L eonardo was different – very different. His thought processes and working methods were strikingly dissimilar from other people, both of the Renaissance period and today. It should come as no surprise then, that several 20th-century mental health professionals have attempted to diagnose Leonardo with illnesses.

ADHD
Attention deficit hyperactivity disorder or ADHD is a relatively

new diagnosis. Classic symptoms of ADHD include being easily distracted, often failing to finish projects, and frequently shifting from one activity to another. Leonardo certainly fits the pattern of finishing little that he started; he left behind plenty of incomplete paintings and other projects he never even started. Leonardo explained this shortcoming with the fact that his range of interests was so large and varied that he simply had too much that he wished to do.

Dyslexia

Another modern disorder that could have affected Leonardo is dyslexia, a learning disorder causing the sufferer to transpose the locations of letters within a word, or write individual letters backwards. It can also cause difficulties in reading as dyslexics can see words as a jumble of letters in a mixed-up order, rather than a particular pattern. Many dyslexic people who are left-handed actually write in a backwards hand similar to Leonardo's and Leonardo's spelling was often strange and erratic.

Bipolar disorder

A third modern diagnosis that has been applied to Leonardo is bipolar disorder. Formerly known as manic-depressive disorder, this psychological condition produces periods of manic behaviour, during which the individual is full of ideas and enthusiasm and often works nonstop on various projects. These periods alternate with times of depression, where the individual seems unable to accomplish a thing.

It is possible that this condition could explain some of Leonardo's behaviour. Reports of his work habits indicate that he did go through long periods of not working, followed by times of obsessive activity where he would toil on a project day and night. Other aspects of Leonardo's work habits and personality also fit the bipolar diagnosis such as not finishing things he started and his many grandiose plans, many of which never came to fruition.

In sickness and in health
An all-round healthy individual

Leonardo appears to have led a generally healthy life and he didn't succumb to early illness and death, as did so many in the plague-ridden 15th century. Life expectancy in Renaissance Italy was around 40 years of age, so by living to 67 years old Leonardo far exceeded the average for his time. He was, it seems, an all-around healthy individual, and it is now believed possible that his vegetarianism may well have contributed to this good health.

Leonardo was also rumoured to have been very strong – supposedly one of his favourite party tricks was to bend a horseshoe using just one hand. He was incredibly proud of his strength and it would have come in extremely handy as an artist. Working with heavy wooden panels could not have been easy, and any young painter would have had to make and carry his own supplies. Moreover travelling with the army of Cesare Borgia required large amounts of physical labour, and Leonardo would have had to be in good shape to keep up with the

warlord's band of warriors. Leonardo likely suffered from the paralysis of his right hand in later years – if caused by injury, this most likely occurred during his time spent with Cesare Borgia.

Inevitably Leonardo's health began to falter as he approached old age, and he is believed to have suffered a stroke in around 1516. Some historians believe this stroke could have caused the partial paralysis of Leonardo's right hand, if the damage had not already been caused by his time with Borgia. In any case he was forced to adopt a slower pace of working during his final years with François. Although not required to do any commissioned work, Leonardo still had full use of his left hand and spent considerable time sketching and working on his notebooks. Even a potentially devastating set back could not completely slow down Leonardo, nor could it put a stop to his artistic activities.

LAST DAYS
Leonardo's health became progressively worse during his last few weeks in 1519. He was apparently so frail

Francois I at the bedside of the dying Leonardo

that he was unable to stand without support. Leonardo was so grateful for King François' periodic visits to his chamber that he would sit up in bed whenever the King came to his side. During those final days Leonardo concentrated on amending his will, taking care of his final religious and civic responsibilities.

A man out of time
An enigmatic legacy

In his day Leonardo was a highly esteemed artist; even with his dubious track record of seldom-completed paintings he was sought after for commissions throughout his life. He was also highly regarded as an engineer, especially during his years with Ludovico Sforza and Cesare Borgia.

In contrast, Leonardo's scientific pursuits seem to have been far more enigmatic. Because his anatomical

drawings required the dissection of cadavers, a practice forbidden during his time in Rome under the patronage of the Pope, this work necessarily required something of an illicit nature. Combined with Leonardo's inherent tendency towards secrecy, contemporary lack of approval likely made this illicit scientist even less inclined to share his discoveries with others.

Today Leonardo is largely remembered and celebrated as an artist – his masterpiece *Mona Lisa* is one of the most recognized paintings in the world, gracing products of all kinds from postcards to mouse pads. His other paintings are not quite as well known, perhaps because so many of them were unfinished or poorly preserved. This limited availability of paintings, along with their often-mysterious nature, seems only to increase both Leonardo's mystique and the collectability of his preserved works.

In large part because of Leonardo's secretive nature, few of his inventions or scientific discoveries have had significant historical influence. Most of his inventions were never built, and rather than sharing his plans and designs with others Leonardo recorded them only in his notebooks. Leonardo's caution in sharing his discoveries led to the eventual dispersion and loss of much of his work.

Leonardo could have rightfully taken his place as one of the 15th century's primary innovators, ushering in a new age of invention and innovation in the Renaissance. Instead Leonardo stands in history as an enigma, a man ahead of his time and out of step with the world around him. It is astonishing to look at the creations in his notebooks, some of which were not conceptualized again until 500 years or so later.

Sincerest form of flattery
Imitation as an art form

Renowned as one of the most celebrated artists of his day, who wouldn't want study with Leonardo? Certainly plenty of his contemporaries did, joining his workshop in the hope that some of the great master's talent would rub off on them and that they would learn to emulate his style.

At various points in his life Leonardo had a workshop full of students, assistants and apprentices. Yet Leonardo's style proved far more than just a new method to copy, and not one of his students seems to have fully mastered his technique. Many works by students in Leonardo's studio bear trademarks of Leonardo himself, and it is easy to imagine the master reviewing the unfinished paintings of his students, even applying his own brush to a troublesome area in order to demonstrate a technique.

One such painting, which is clearly not by Leonardo yet bears some traces of his style, is *Portrait of a Young Woman*. This painting of a stiff profile view is utterly unlike the naturally

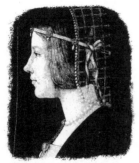

Portrait of a Young Woman *by Ambrogio de Predis*

posed three-quarters views that Leonardo favoured in his portraits. It was most likely painted by Leonardo's collaborator and student Ambrogio de Predis between 1495 and 1500. Yet some details of Leonardo's influence are visible in the elaborate headdress worn by the young woman, as well as her pearls and elegantly tied ribbons. Leonardo's influence clearly inspired and aided de Predis, for during his time in association with Leonardo he produced his two best works – the aforementioned portrait and another portrait entitled *Bartolommeo Archinto*.

A similar story applies to Leonardo's other students. Many tried to imitate Leonardo over the years, but with little or no success. Some hallmark elements of his works – enigmatic smiles and misty backgrounds – are relatively simple to replicate. However the sense of serenity and depth present in a work like *Mona Lisa* are far more difficult to emulate. Leonardo's paintings have an inner wisdom as well as a darkness that makes them seem to come alive. No one before or since has been able to reproduce the signature mystery of a Leonardo original.

The real deal
The truth behind The Da Vinci Code

Leonardo da Vinci has captivated the world for centuries, but he recently achieved a new level of popularity with the publication of Dan Brown's wildly successful novel *The Da Vinci Code* in 2003.

In brief, this novel leads the reader through a historical murder mystery tour, discovering clues in various artifacts such the Holy Grail and paintings such as the *Mona Lisa* and *The Last Supper*. Brown asserts that these and other works by Leonardo are filled with hidden meanings and cryptic messages. Brown also explores an ongoing rumour that Leonardo belonged to a secret society devoted to hiding the 'truth' about Christianity.

Many people have wondered whether the whole story might be true. Could there actually have been a conspiracy throughout the ages, and a secret society of which Leonardo da Vinci himself was a member, charged with protecting secrets from Christianity's earliest days? If

it actually existed, Leonardo would have been a prime candidate to leave historical clues to such a conspiracy with his penchant for puzzles, love of secrecy, and superior intellect. Moreover the works of art, as well as the secret societies mentioned in the novel, do actually exist. Yet there is a world of difference between their mere existence and the likelihood of a conspiracy.

True enough, the societies mentioned in the book such as the Priory of Sion, the Knights Templar and Opus Dei are real societies that exist in the real world. However there is no evidence that these societies were involved in a plot to conceal the Holy Grail. And while scholars have analyzed Leonardo's *Mona Lisa* and other artists' works for centuries, searching for hidden codes or other secrets, they haven't uncovered one of significance. Leonardo was certainly interested in codes and mechanical devices, so it's possible he might have invented a message delivery device such as the cryptex mentioned in the book – but there is no historical evidence that he actually did so.

The secrets of Christianity

alluded to in *The Da Vinci Code* are controversial, to say the least. The novel suggests that the individual to the right of Jesus in Leonardo's painting of *The Last Supper* is actually Mary Magdalene, a theory that has remained popular over many years. Yet most art historians believe that the disciple in question is actually John, depicted in the androgynous form favoured by Leonardo in this and other works. Not only is there no evidence that Mary Magdalene was included in this painting, it's unlikely that Leonardo was attempting any allusion to her body as the Holy Grail by including her and not a chalice in the painting. There is no concrete evidence to suggest that she and

Jesus were ever married and, more importantly, a reference to Jesus and Mary Magdalene would have been in direct contradiction to the religious doctrine of the time.

Another so-called secret explored in *The Da Vinci Code* is the role of anagrams in the name of Leonardo's most famous painting. The title of the painting *Mona Lisa* is undoubtedly an anagram for 'Amon L'Isa' – however it is also an anagram for 'Man As Oil', 'Animal So' and hundreds of other possibilities in various languages. In this light, it's a stretch to imagine that Leonardo intended any reference to the ancient Egyptian gods – it is unlikely that he even had any knowledge of these deities.

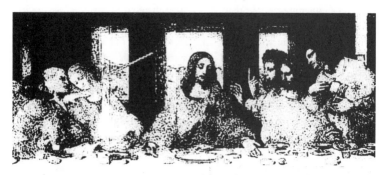

The Last Supper

So it's important to keep in mind that although works like *The Da Vinci Code* are fun escapes from reality, they're ultimately just fiction. Of course, the interest that Brown's novel sparked in general art history and Leonardo in particular has undoubtedly been a good thing.

Quintessential Renaissance man
A truly astounding individual

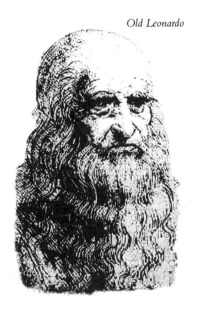

Old Leonardo

As the Renaissance gradually took hold during the 15th and 16th centuries the division of art forms, and the depth of knowledge that surrounded each, became more pronounced. At the same time general knowledge was still fairly limited compared to modern standards and because of this limitation it was possible to be expert in many different fields at once.

Leonardo was considered one of the earliest and greatest of Renaissance men not only because he studied a diversity of subjects, but also because he become amazingly adept at them too. He wasn't simply a dabbler in painting and architecture;

he was a highly skilled creative whose work remains unrivaled to this day. He was considered an expert in not just art, but also mathematics, invention, engineering and construction. He also became a talented writer – his own notebooks are one of our best sources of information about his life and career as well as his ideas. Leonardo's inventions may seem primitive in light of modern technology and science, but for the Renaissance they

were utterly astounding. What is most unusual is that many of his designs were advanced enough to have been innovative even 500 years later.

Leonardo was certainly one of the great painters of his day, but did he really have the same amount or level of competition that artists today have? How would he hold up against modern-day scientists? There's no easy answer here – nor is one needed. Leonardo's work speaks for itself and even today the breadth and depth of his knowledge would set him apart. Suffice to say that Leonardo was in all respects an original – the quintessential Renaissance man.

TOP OF THE POPS

In 1999 BBC News Online ran a series of polls to establish popular opinion on the greatest men and women to live in the last millennium. In response, thousands of voters took part in the polls from all over the world. The poll in March 1999 took the greatest painters to task. Two experts were asked for their views, . Alan Borg and Sir Roy Strong, who chose Jan Vermeer and The Master Builder of Chartres respectively. However BBC News Online voters begged to differ, and it should come as no surprise to discover that Leonardo was voted in at the top spot.
The 'greatest artist' countdown ran as follows:

1. Leonardo da Vinci
2. Michelangelo
3. Pablo Picasso
4. Vincent Van Gogh
5. Salvador Dali
6. Jan Vermeer
7. Claude Monet
8. Rembrandt
9. Raphael
10. Giotto

Index

Picture Credits

Images on following pages adapted from work by:
p12 Tom and Louisa, p26 Sailko, p58 goatling, p64 claude V8, p111 Ric Heil

MORE AMAZING TITLES

LOVED THIS BOOK?

Tell us what you think and you could win another fantastic book from David & Charles in our monthly prize draw. www.lovethisbook.co.uk

AMAZING & EXTRAORDINARY FACTS:
THE BRITISH AT WAR
JONATHAN BASTABLE
ISBN: 978-0-7153-3899-5

AMAZING & EXTRAORDINARY FACTS: GHOSTS
MALCOLM DAY
ISBN: 978-0-7153-3909-1

AMAZING & EXTRAORDINARY FACTS:
TRAINS & RAILWAYS
JULIAN HOLLAND
ISBN: 978-0-7153-3622-9